MIRAMICHI
magic

PHOTOGRAPHY BY CATHY CARNAHAN

FORMAC PUBLISHING COMPANY LIMITED

This book is dedicated to my father, Earl McGregor, who I know is in heaven watching over me. It is also in loving memory of my grandparents, Murdock and Catherine Sutherland. It was at their small farm on the banks of the Sevogle that I first discovered Miramichi Magic.

Formac Publishing acknowledges the support of The Canada Council and the Nova Scotia Department of Education and Culture.

Canadian Cataloguing in Publication Data
Carnahan, Cathy, 1961-
Miramichi magic
ISBN 0-88780-380-6
1. Miramichi River Valley (N.B.) — Pictorial works. I. Title.
FC2495.M48C37 1996 971.5'21 C96-950144-7
F1044.M5C37 1996

Formac Publishing Company Limited
5502 Atlantic Street,
Halifax, Nova Scotia,
B3H 1G4

Printed and bound in Canada.

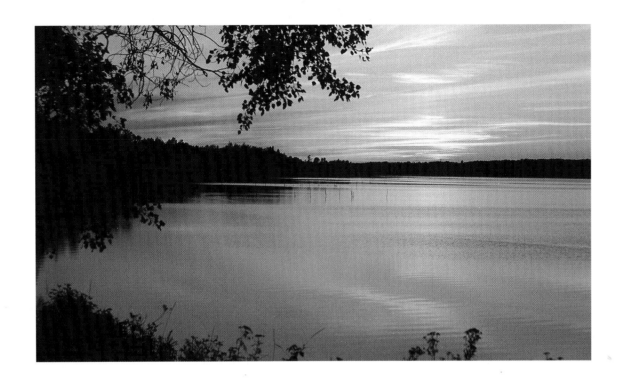

Contents

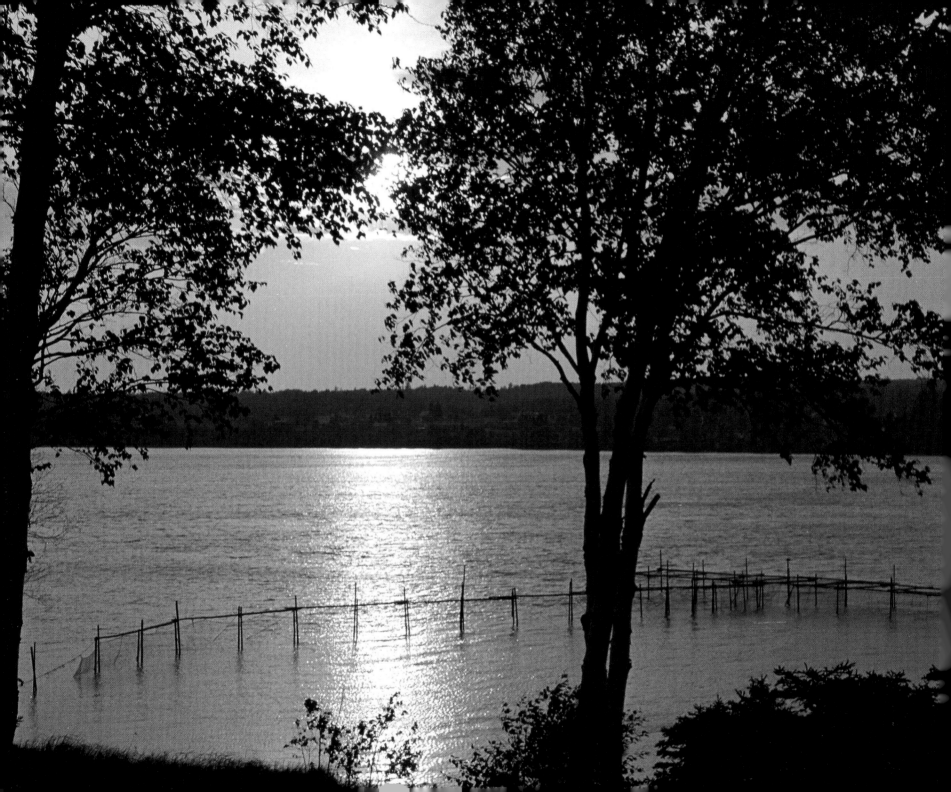

Introduction

Welcome to my home, the magical Miramichi.

This year, 1995–96, the Miramichi celebrated an historic event: the amalgamation of eleven communities to create New Brunswick's fourth-largest municipality — the City of Miramichi. This book is a salute to the region and the new city that are linked historically, geographically and culturally by the mystical Miramichi River. It is also a tribute to my people: whether we live within the City of Miramichi itself, "up the river," "down the river" or in outlying areas, we are all proud to be Miramichiers.

New Brunswick is sometimes said to be the "unknown" province of Canada, but we are attempting to change that. The Miramichi area here in eastern New Brunswick is particularly blessed with a variety of traditions and cultures. Celebrations are a trademark of the region. The Irish Festival on the Miramichi is internationally famous; the week-long Miramichi Folksong Festival claims to be North America's oldest festival and features music, food, workshops and fiddling championships; the Miramichi Highland Weekend celebrates the region's Scottish heritage; and the annual Miramichi Agricultural Exhibition and the Napan Agricultural Show are favourite summer attractions. Alcohol- and drug-free powwows sponsored by the area's First Nations reserves also foster pride in native traditions with their drumming, dancing and chanting.

Our province is rich in natural resources and beauty. From my haven in the Miramichi, I am reminded of this every day of the year. Even during the coldest winter, I can look around and feel warmth from the blanket of beauty surrounding me. In the spring, I watch the return of the Canada Geese and listen to frogs sing. I walk in the woods and savour the sights and sounds of

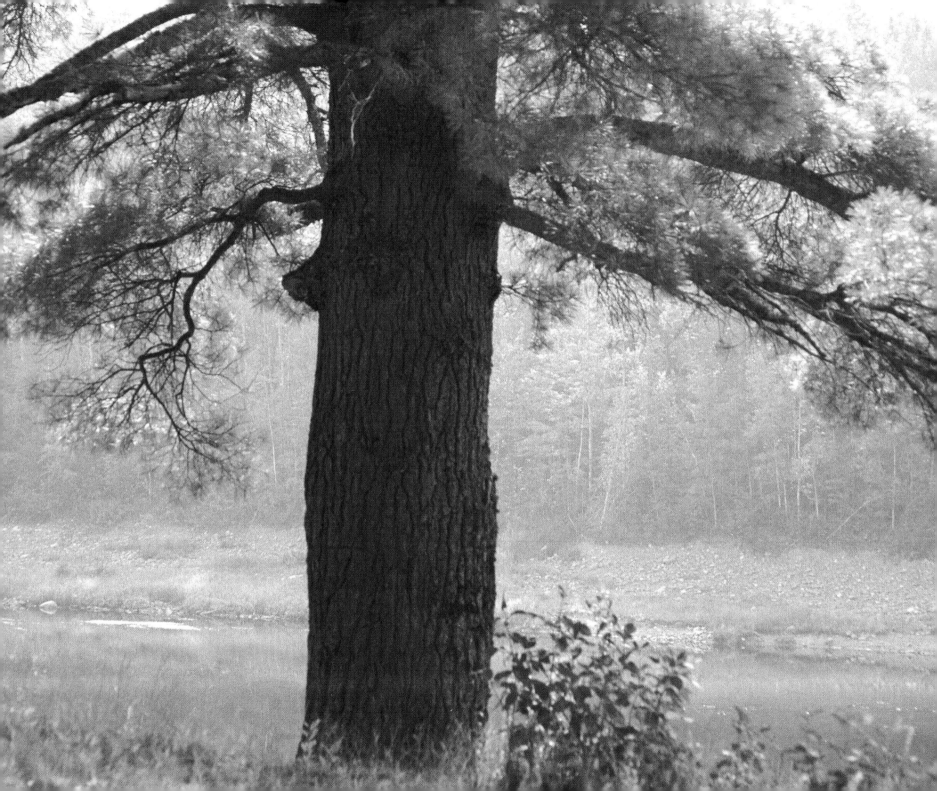

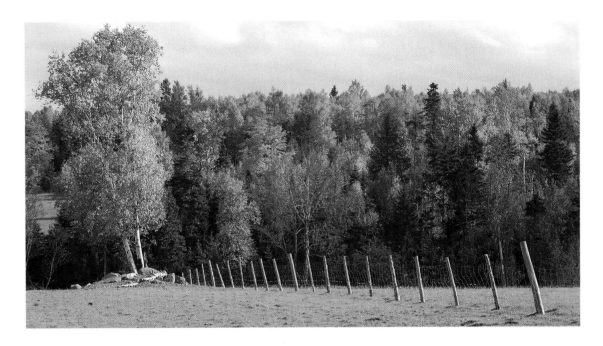

the newborn forest — and the promise of new beginnings. Summer brings wild strawberries and delicious shortcake. When the evening sun turns the mighty Miramichi into spectacular shades of the rainbow, I catch my breath. Autumn heralds a time to harvest fruit and reminisce as leaves turn from a luscious green to crimson red and a last burst of brilliant yellow.

The splendour of nature is everywhere on the Miramichi, from the banks of our world-famous salmon-fishing river to the harmony of our forests, farms, and communities. Together, they create this special place. As I look at the river, I am thankful to be here, and feel an ever-stronger connection with what came before me.

I hope that you, too, will feel part of that divine connection as you leaf through the pages of this book. I invite you to enjoy a trip along the river, from the Miramichi headwaters in the "Upriver" section, to "The City and the River," to the outer margins of the bay in "The Bay and Beyond." Stop and visit with neighbours and friends — you'll find their familiar faces throughout. Most are not rich or famous. They are craftspeople, fishers, farmers, musicians, children, labourers and entrepreneurs — simply the quiet, proud Miramichi folk who make this region unique.

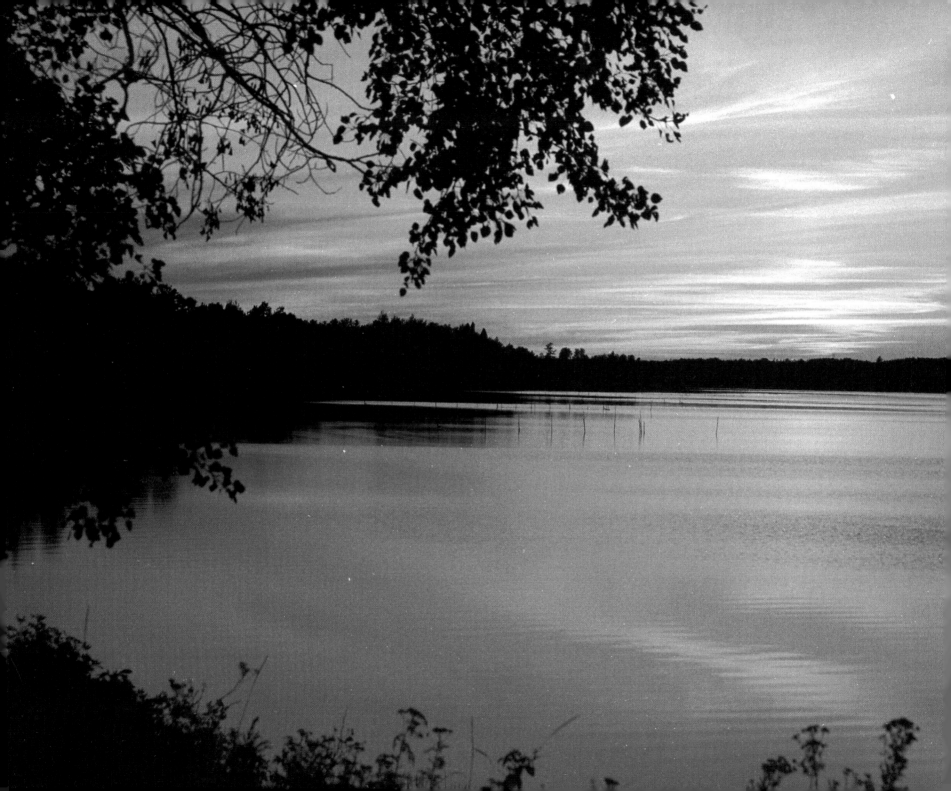

A Brief History

The Miramichi River valley has a long and colourful history. Mi'kmaq Indians lived in the area for thousands of years before the arrival of the first Europeans in the 1600s. In fact, the word "miramichi" is said to be derived from a word meaning "Mi'kmaq land." Some say the word also means "place of happy retreat," and all those who live along the river certainly agree with that description.

After 1600, many English, French, Irish and Scottish settlers put down roots and called the Miramichi home. Today, their descendants boast of a rich heritage and culture and find it difficult to imagine that when Nicolas Denys was granted the seigneury of Gaspesia in 1648 — a grant that included the Miramichi River valley — the non-native population of the entire region numbered only 200. Denys traded with the Mi'kmaq and established fishing and trading stations and, over the following 100 years, the population remained stable while the land passed between the control of the French and the British.

Then, in 1755, Charles Boishebert arrived from Fort Beausejour in the south, bringing with him thousands of Acadians who had fled for their safety after the fort fell to the British. Boishebert set up a refugee camp on an island along the Miramichi (it was later named "Beaubear" in his honour), where thousands of people crammed themselves into 200 houses. Their stay, however, did not last. British marauders pursued the Acadians and, in 1760, Commander Byron demolished the settlement. Many Acadians fled, but those who did remain and rebuild their homes forged a durable legacy for their descendants.

In 1765, life along the Miramichi entered another, more prosperous phase. In that year, William Davidson and John Cort were granted 10,000 acres to cultivate and thereby draw settlers. It has been said that the Miramichi is a land to fire the imaginations of adventurers — and none more so than the region's first entrepreneur, William Davidson. Not content to be a landholder and farmer, Davidson soon began to fish and then to build ships to export his catch. He built New Brunswick's first schooner — "The Miramichi" — and became a prosperous shipbuilder. Eventually, the American Revolution drove Davidson southward to Maugerville along the Saint John River, but he returned to the Miramichi in 1783 and continued to build ships, fish and log.

These activities attracted about 200 Scottish and Irish immigrants throughout the 1780s. In 1792, entrepreneurs James Fraser and James Thomson started up yet another industry in the region: exporting lumber.

By 1825, the Miramichi had a population of 1,000. Then, in the fall of that year, disaster struck in the form of the Great Miramichi Fire. The fire claimed 200-300 lives and destroyed many buildings. The region's settlers did not allow this tragedy to deter them for long. Within a little more than a decade, the Miramichi was prospering again with growth in the timber and shipbuilding industries. This resulted in rivalry between lumber barons Alexander Rankin and Joseph Cunard, who competed for markets and rights to woodlots and provided most employment in the area. The competitors inspired fierce loyalties among workers and residents even as they laid the foundations for the prosperity and stability that Miramichi communities enjoyed throughout the 1800s.

The Communities of the Miramichi

Chatham was incorporated in 1896 and is thought to have been named by its founder Frances Peabody, in homage to William Pitt, the Earl of Chatham.

Newcastle was incorporated as a town in 1899 and was named by its first sheriff, Benjamin Marston. According to legend, Marston possessed a degree from Harvard but found the town's original name — Miramichi — difficult to say and spell and so changed it to "Newcastle."

Douglastown was incorporated as a village in 1967, Canada's centennial year. Originally called Gretna Green, the community's name was changed in 1825 in honour of a visit by the province's lieutenant-governor, Sir Howard Douglas.

The village of Loggieville was named after the Loggies, a family of entrepreneurs who established a network of businesses, stores and mills across Canada and the northern United States.

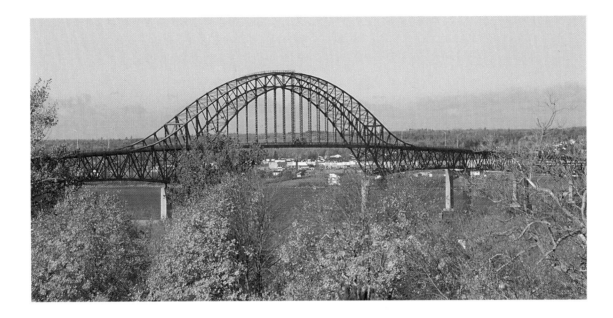

Nelson-Miramichi, which sits across the river from Newcastle and, on the other side, faces Beaubear's Island, was originally named Lower Settlement. The name was changed in 1805 to commemorate Lord Nelson, who died that year at the Battle of Trafalgar. The masts for Nelson's ships had come from Beaubear's Island.

Today, these two towns and three villages, along with six surrounding communities, form the new City of Miramichi. The city was incorporated on January 1, 1995, in a ceremony that marked the end of one era and the provocative beginning of another

Towards the Future

The Miramichi region is home to some 55,000 people; the City of Miramichi alone boasts a population of 22,000. The goal of the city's planners and supporters is to encourage "strength through unity" and to develop greater economic prosperity in the region as a whole. Indeed,

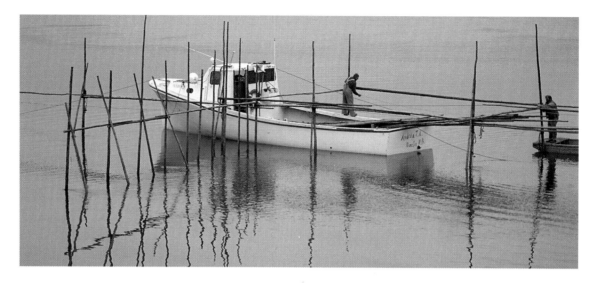

regional development officials predict a Miramichi growth trend in the wake of positive development projects, including a new hospital, a new bridge and highway system, and the upgrading of educational facilities. The New Brunswick Community College in Miramichi has become a global leader in information technologies. At the same time, traditional industries such as forestry, fishing, farming and mining continue to play an important role in the economy of the Miramichi. The new $90 million Eagle Forest Products mill possesses some of the most modern and sophisticated equipment in North America. Photos in this book show Prince Charles visiting the plant in April 1996, to turn the first logs into flakes. It was an historic moment for the company partners, who include Americans, Canadians and eight New Brunswick First Nations.

As I prepared the photos for inclusion in these pages, it became clear to me that, while time and circumstance have changed the Miramichi community in many ways, the pride and entrepreneurial spirit of the people remain undaunted. The final book is a reflection of how I see my community and I hope it will contribute to our pride and spirit, encouraging all Miramichiers to appreciate our history and protect our unique environment. I also hope it will entice visitors to come and share in the beauty and tradition of our land. Most of all, I hope it will inspire all of us to look around and take stock of a place unlike any other in the world. Welcome to the magical Miramichi!

Map of the Miramichi

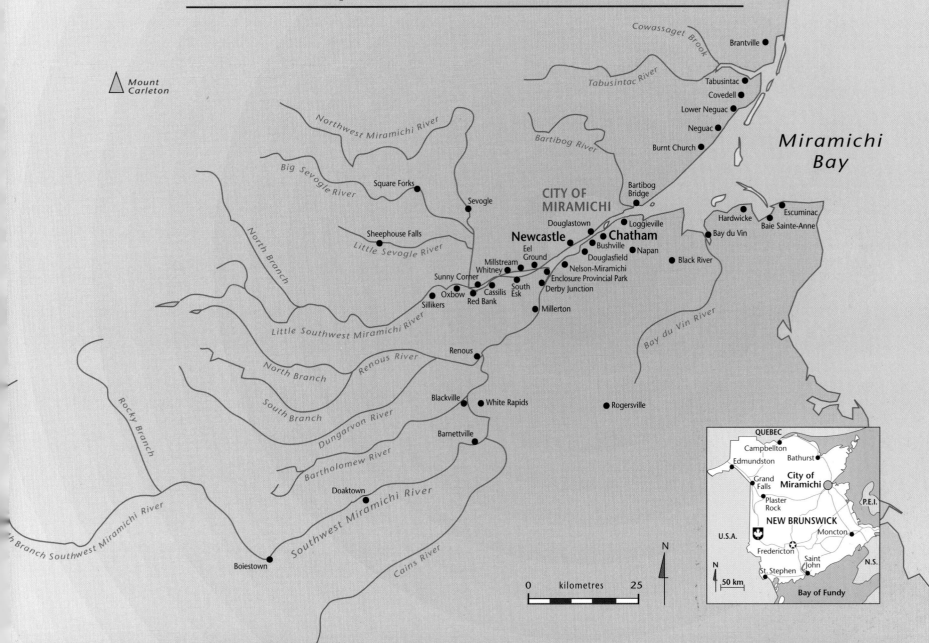

Mount Carleton

Cowassaget Brook

Brantville

Tabusintac River

Tabusintac

Covedell

Lower Neguac

Northwest Miramichi River

Bartibog River

Neguac

Burnt Church

Miramichi Bay

Big Sevogle River

Square Forks

Sevogle

CITY OF MIRAMICHI

Bartibog Bridge

Escuminac

Hardwicke

Baie Sainte-Anne

Sheephouse Falls

Little Sevogle River

Douglastown

Loggieville

Bay du Vin

North Branch

Newcastle

Chatham

Bushville

Eel Ground

Napan

Millstream

Douglasfield

Whitney

Nelson-Miramichi

Black River

Sunny Corner

Enclosure Provincial Park

Oxbow

Cassilis

South Esk

Derby Junction

Silikers

Red Bank

Little Southwest Miramichi River

Millerton

Bay du Vin River

North Branch

Renous

Renous River

South Branch

Dungarvon River

Blackville

White Rapids

Rogersville

Barnettville

Bartholomew River

Rocky Branch

Doaktown

Southwest Miramichi River

th Branch Southwest Miramichi River

Cains River

Boiestown

N

0 kilometres 25

QUEBEC

Campbellton

Edmundston

Bathurst

City of Miramichi

Grand Falls

Plaster Rock

P.E.I.

NEW BRUNSWICK

Moncton

U.S.A.

Fredericton

Saint John

N.S.

N

50 km

St. Stephen

Bay of Fundy

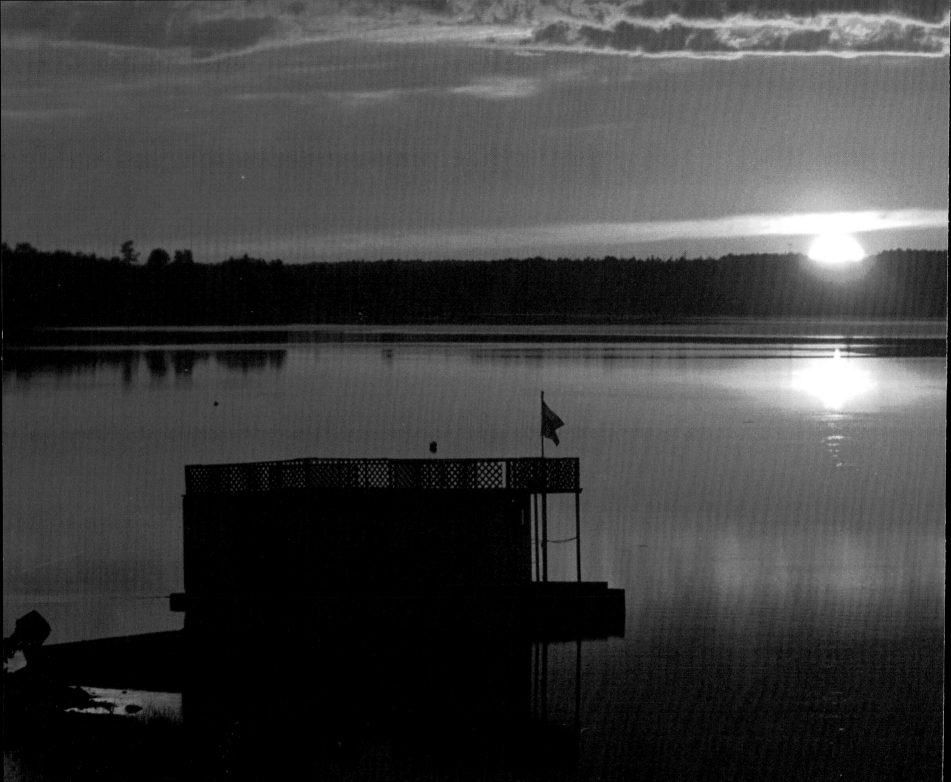

Upriver

The Miramichi River is the heart and soul of the land "upriver." Here you'll find fish and lumber, and unparalleled

outdoor adventure. Travel along the pristine waters of the Southwest and Northwest Miramichi. Visit Sevogle and

the Little Southwest, the small, friendly villages of Doaktown, Blackville, White Rapids, Millerton, Derby Junction,

South Esk, Sillikers and Whitneyville, and the First Nations communities of Eel Ground and Red Bank.

This is our river, our people, our past, our future.

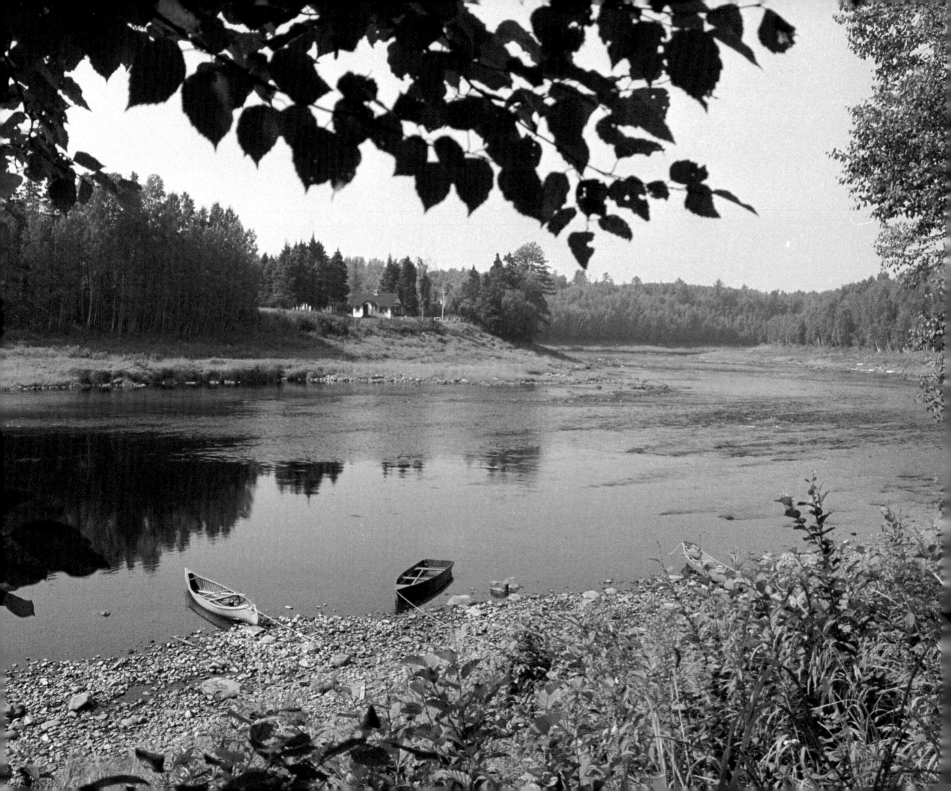

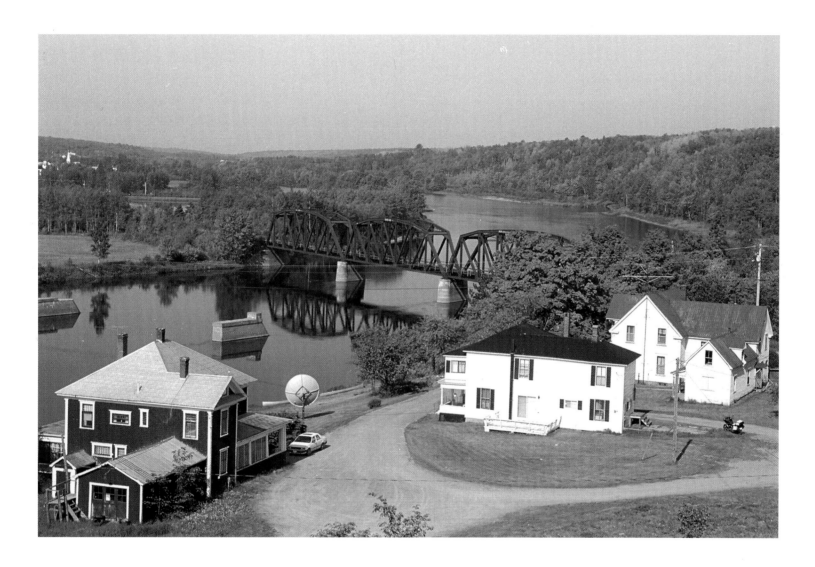

Pastoral scenes at White Rapids (opposite) and Doaktown (above).

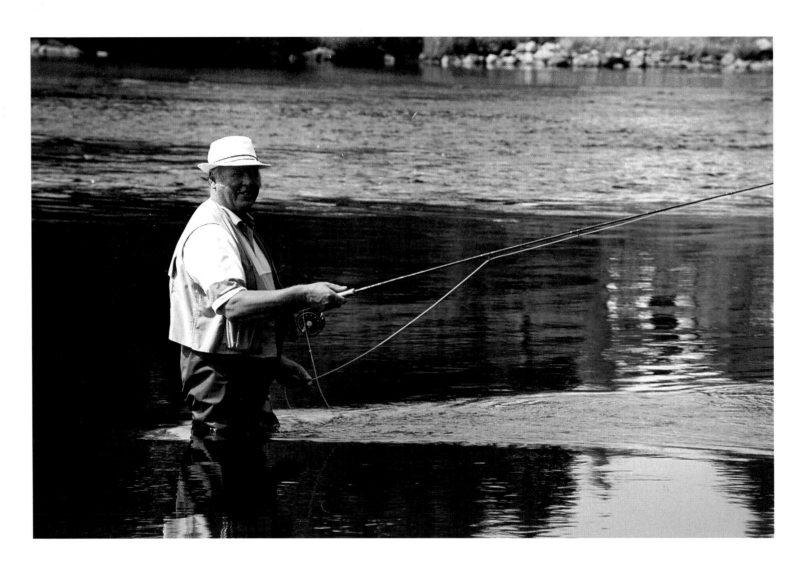

Clarence Tucker of White Rapids fishes for world-famous Miramichi salmon.

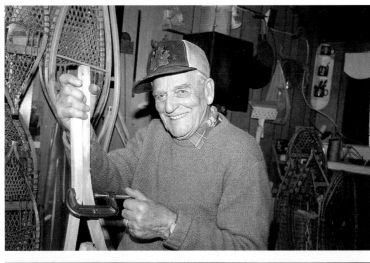

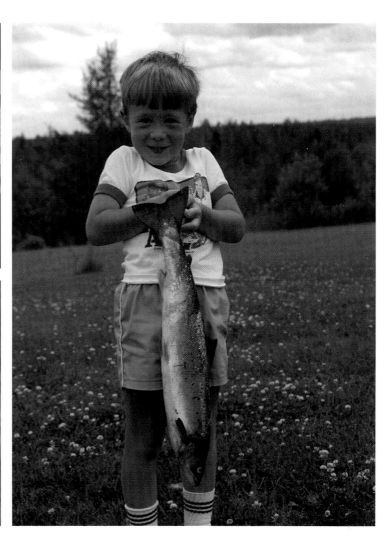

Faces of the Upper Miramichi (clockwise from top left): Blissville's Charlie Gillespie, the "snowshoe man";
Andrew MacKenzie of Whitney, age 5, with a prize salmon; Richard and Celine Massé of Blackville.

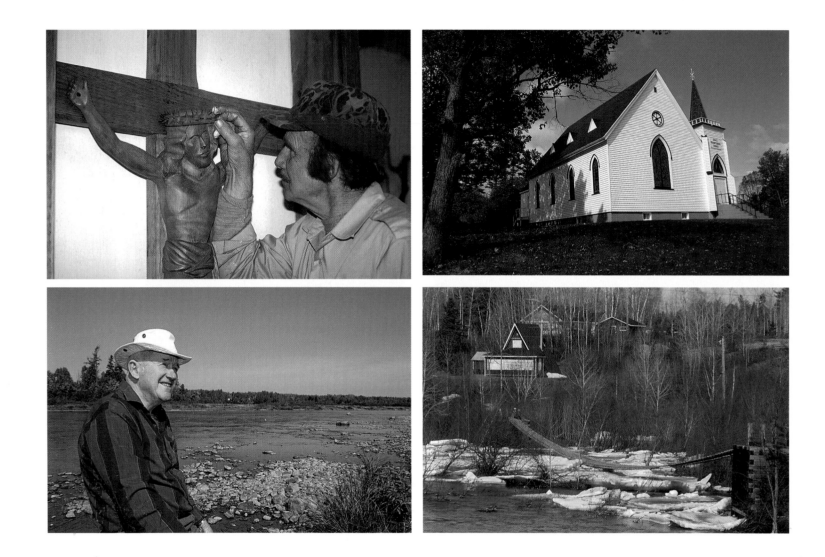

The contemplative life (clockwise from top left): Robert E. Jardine of Barnettville carves a crucifix from 200-year-old white pine;

Grace Presbyterian Church, Millerton; author Arnold Somers of Sillikers. Opposite: The river at Millerton.

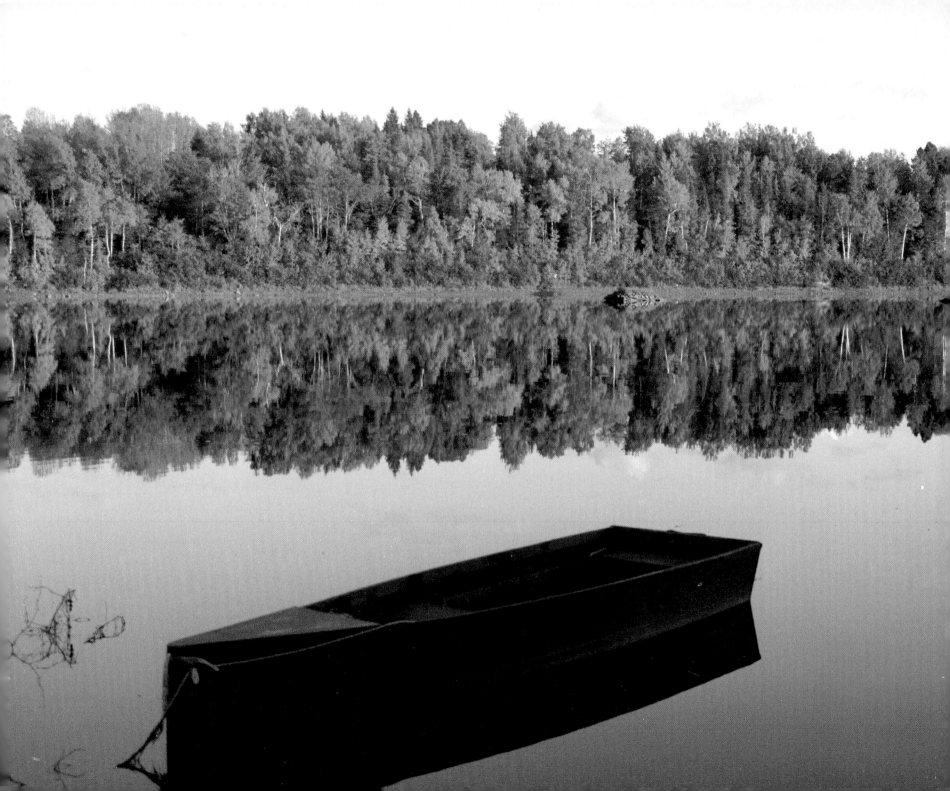

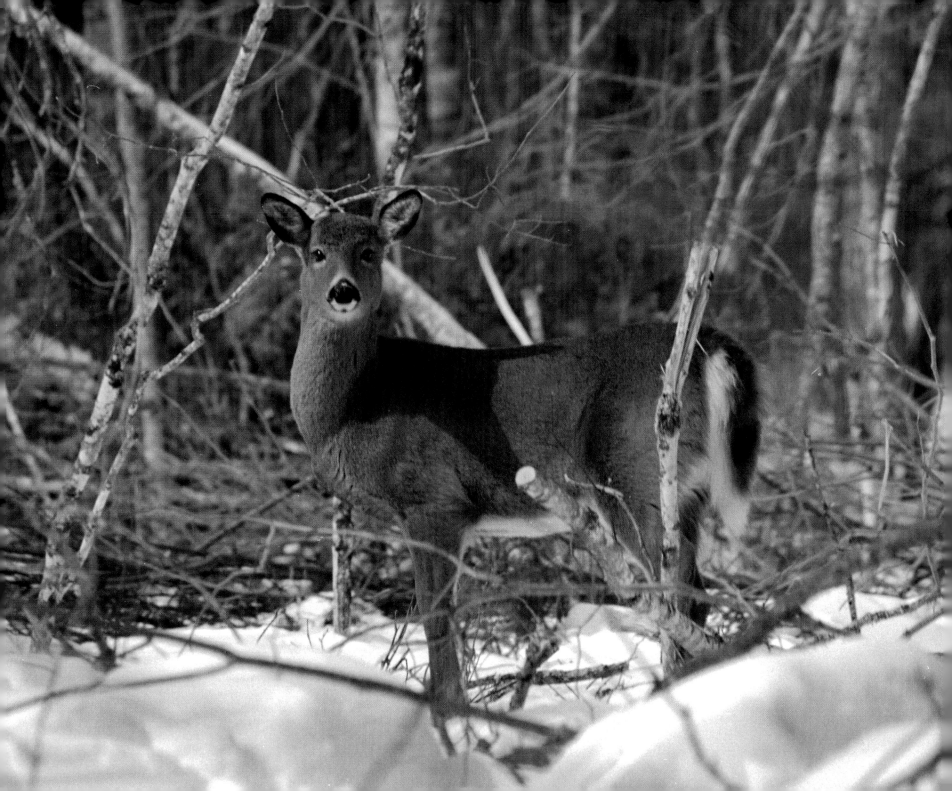

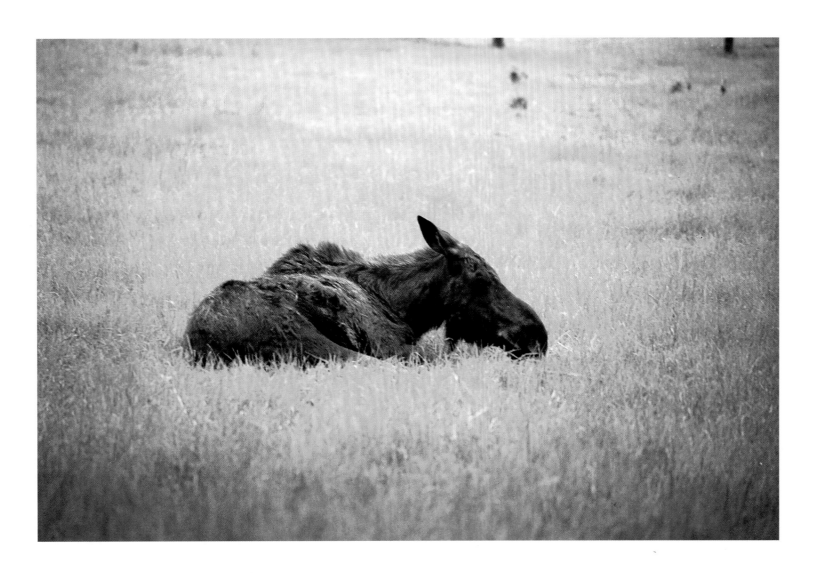

Stolen moments: a startled doe (opposite) and an unconcerned moose (above).

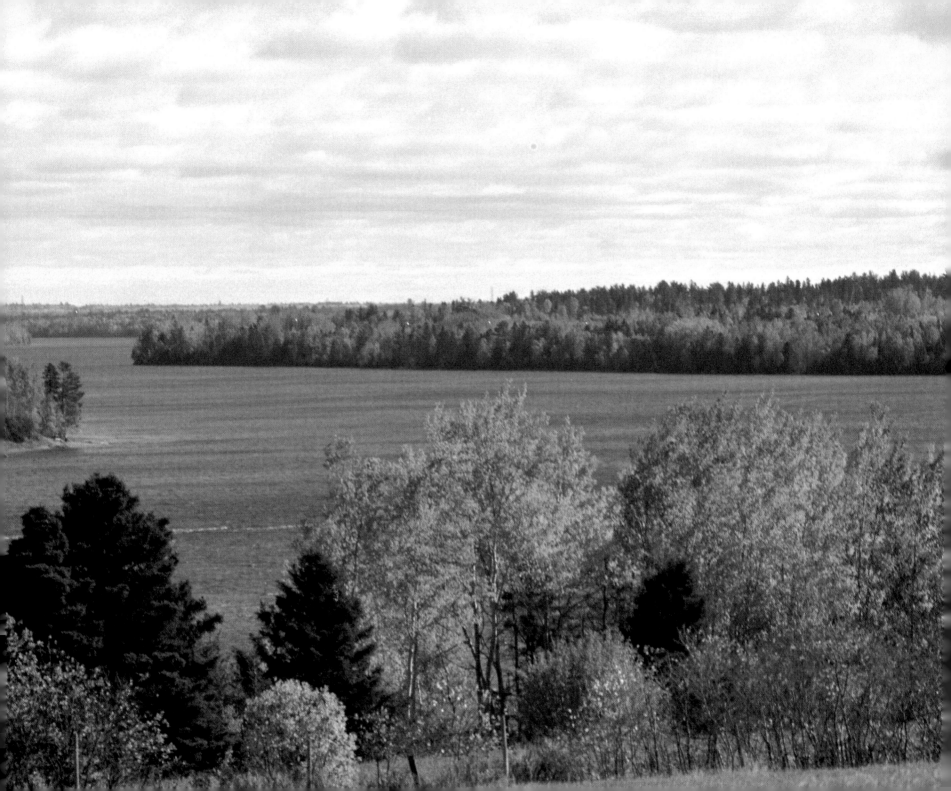

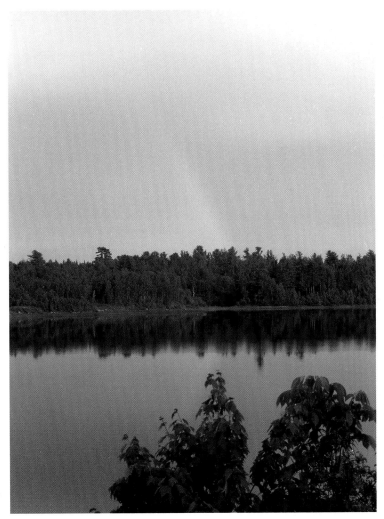

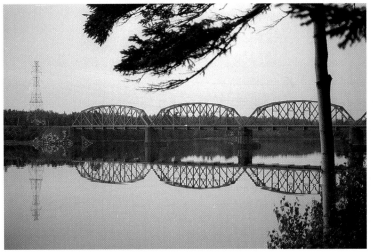

Autumn: along the river at South Esk (opposite) and Millerton (above left); at the Millerton home of former MP
Maurice Dionne and Precille Dionne (top right); the railway bridge at Derby Junction.

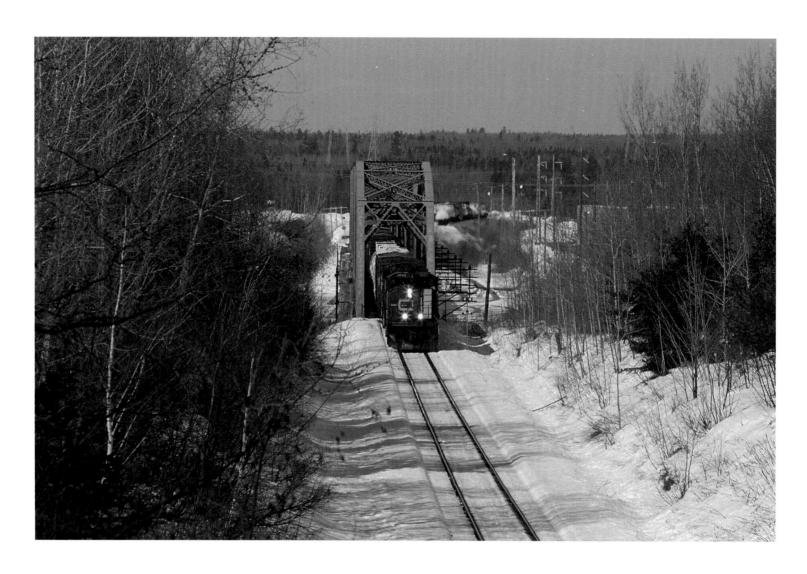

The Derby Junction train.

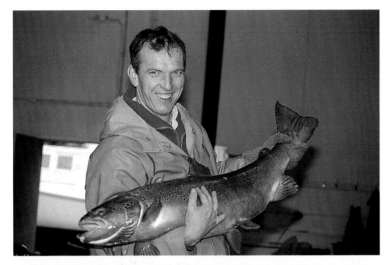

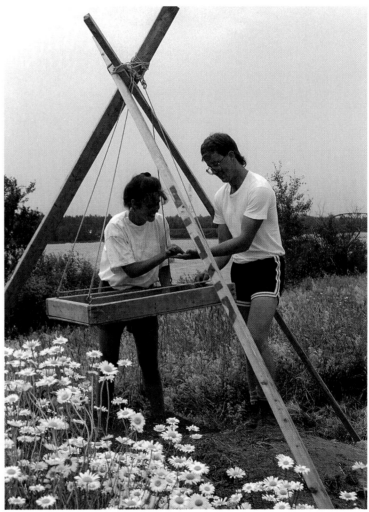

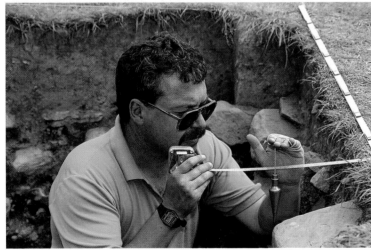

At work (clockwise from top left): Mark Hambrook of the Miramichi Salmonid Enhancement Centre; Archaeologist Marc Lavoie, surveying an historical site at the Enclosure Provincial Park; Andrea Bowes and Bradley Connors sifting for artifacts during an archaeological dig at the Enclosure.

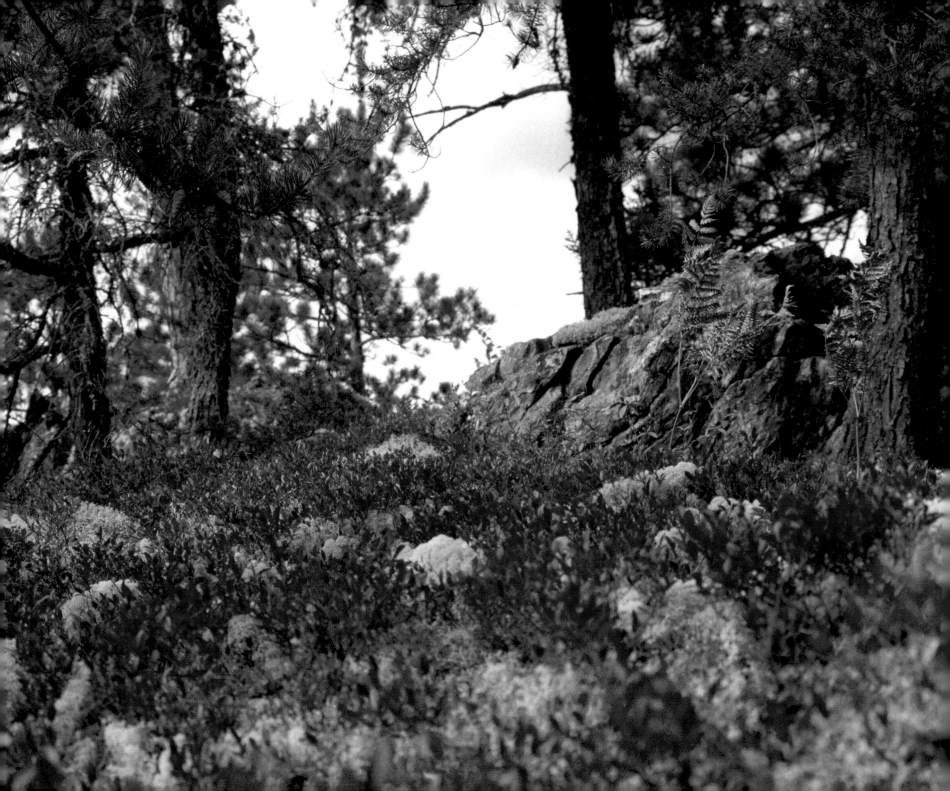

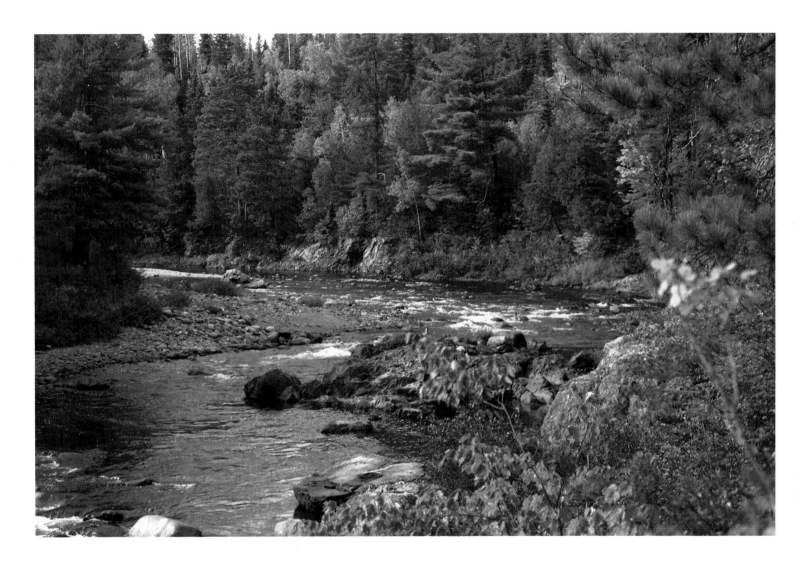

Following the stream: moss along the river (opposite); near Square Forks (above).

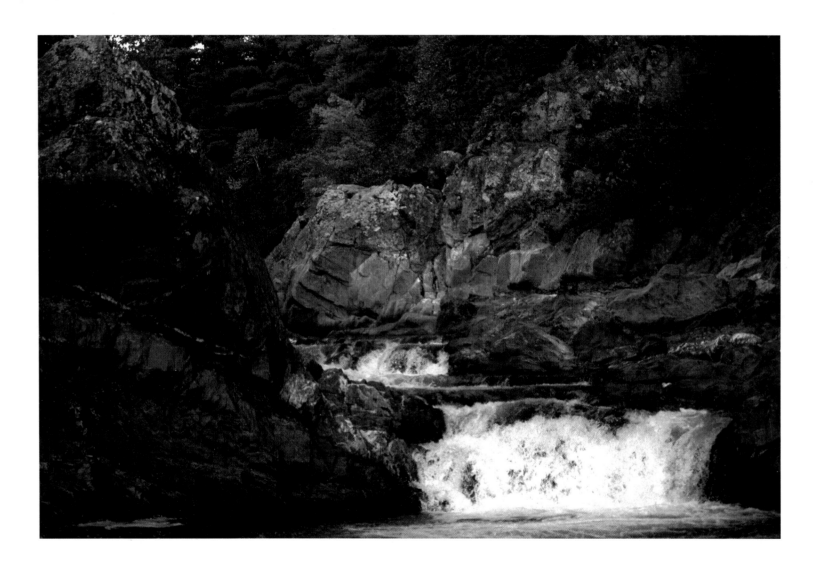

Square Forks splendour.

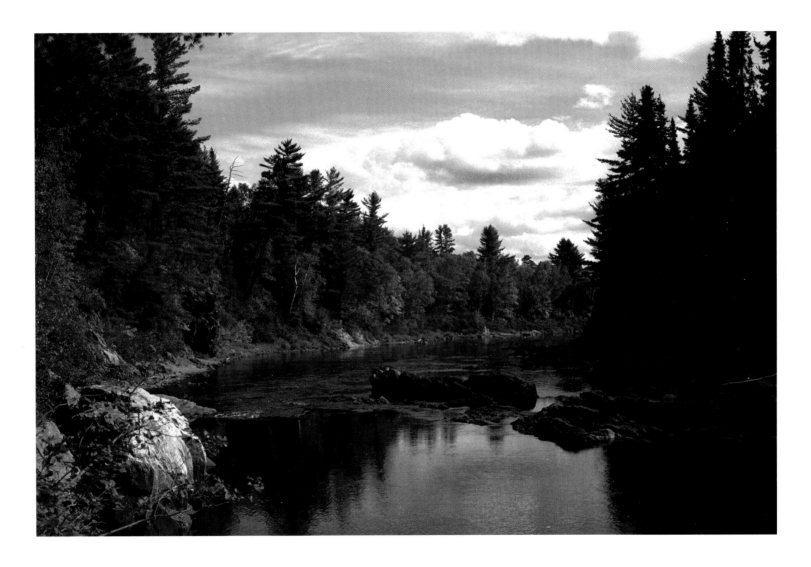

Along the Big Sevogle River.

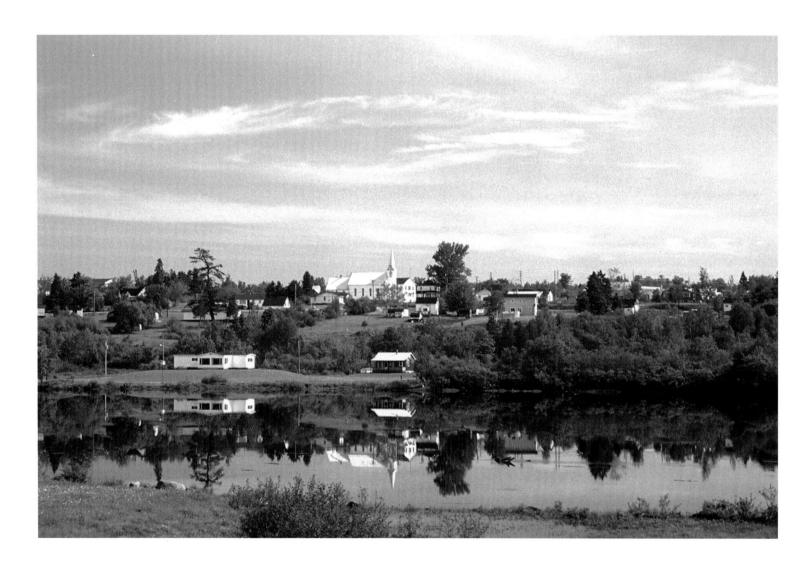

Blue skies: at Sunny Corner (above) and Red Bank (opposite).

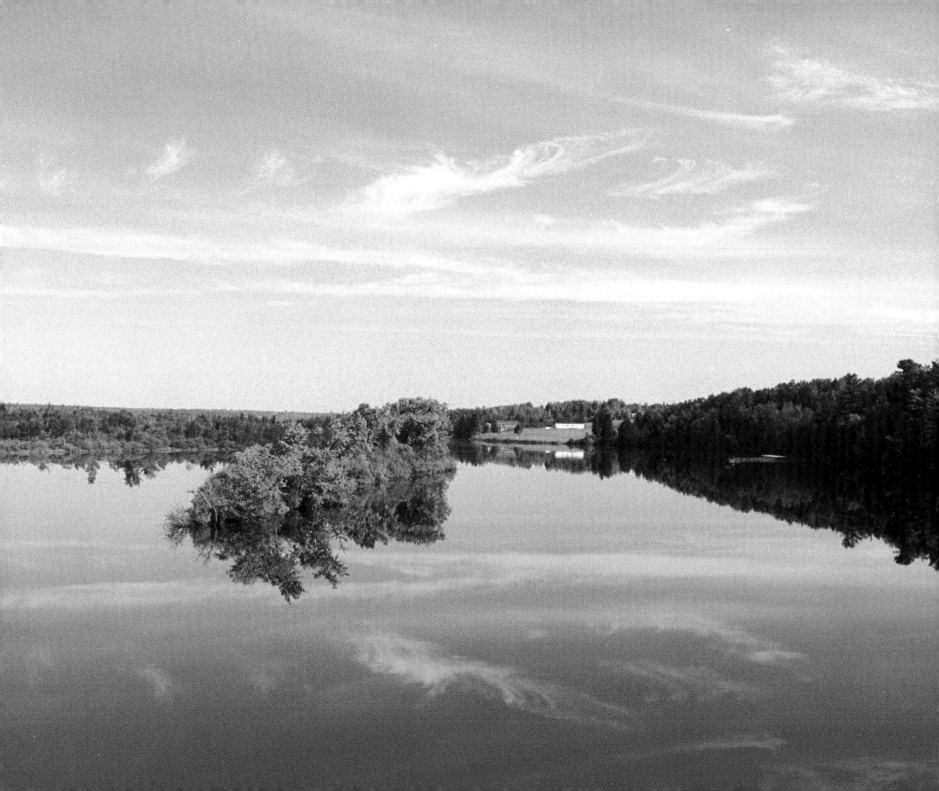

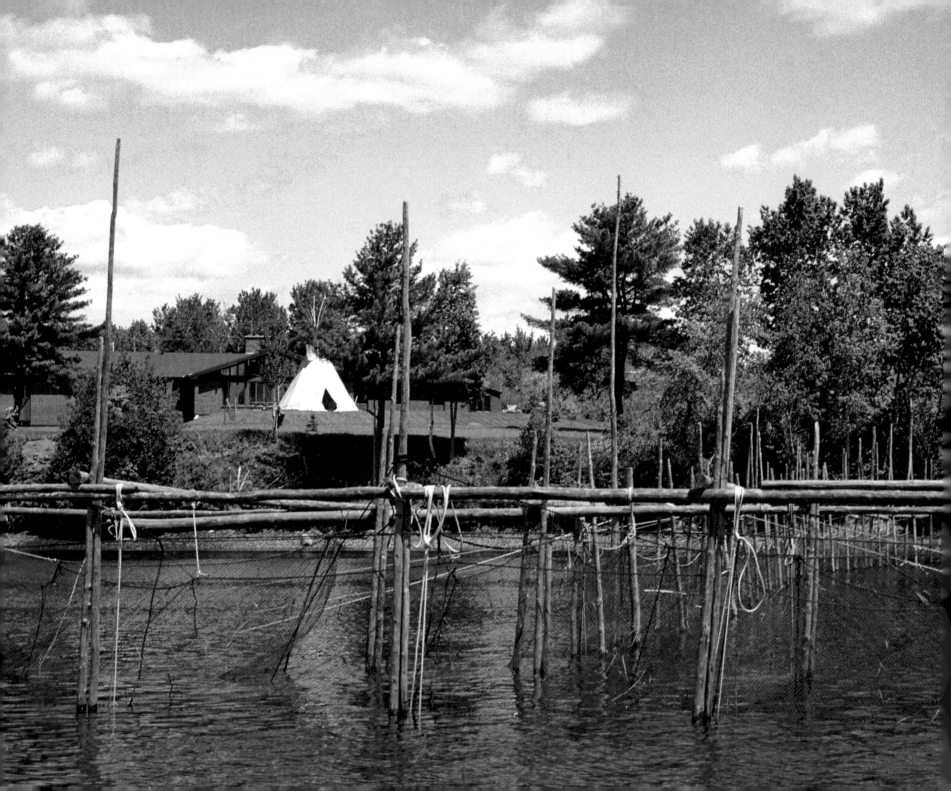

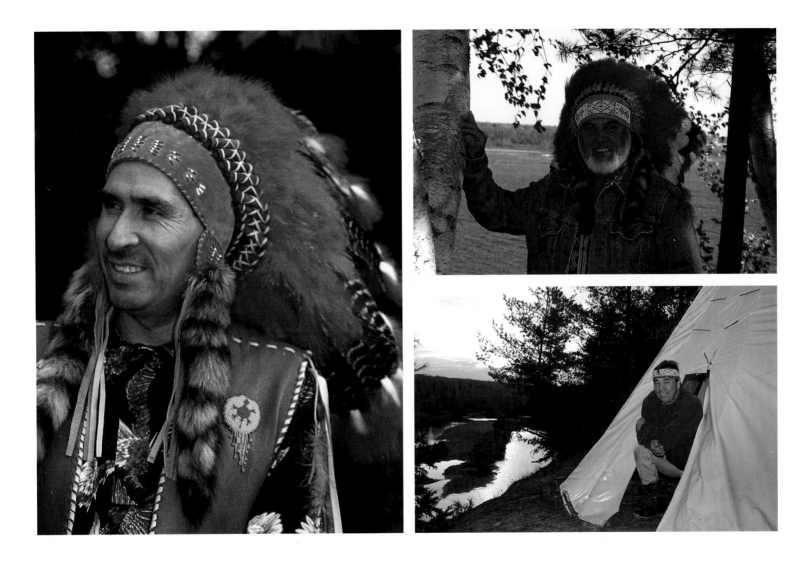

*Mi'kmaq presence (clockwise from left): Michael Ward, former chief of the Red Bank Mi'kmaq; Eel Ground leader Roger Augustine; Howard
Augustine on the banks of the Little Southwest Miramichi; a trap net for scientific research at Eel Ground (opposite).*

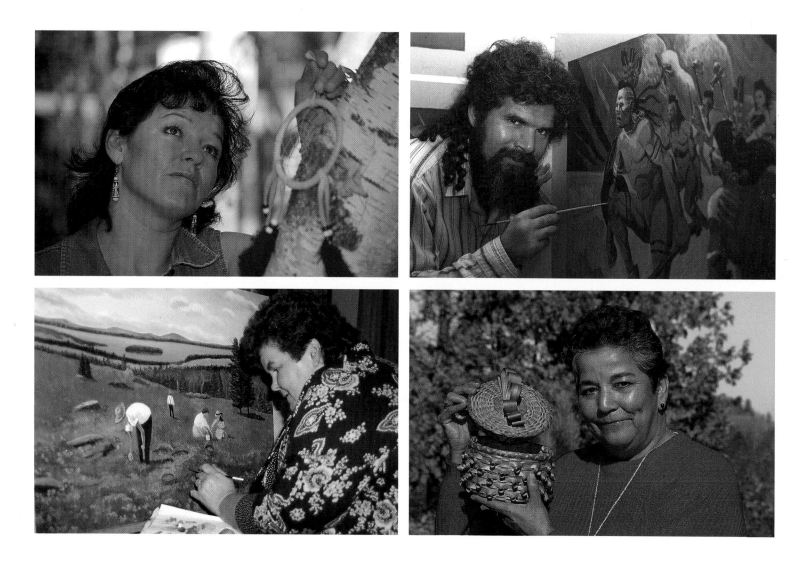

Art and Tradition (clockwise from left): Eel Ground councillor Wanda Ward holds up a dreamcatcher; Red Bank artist Roger Simon;
Madeline Augustine carries on the tradition of Mi'kmaq basket weaving; Sunny Corner artist Lois Sutherland.

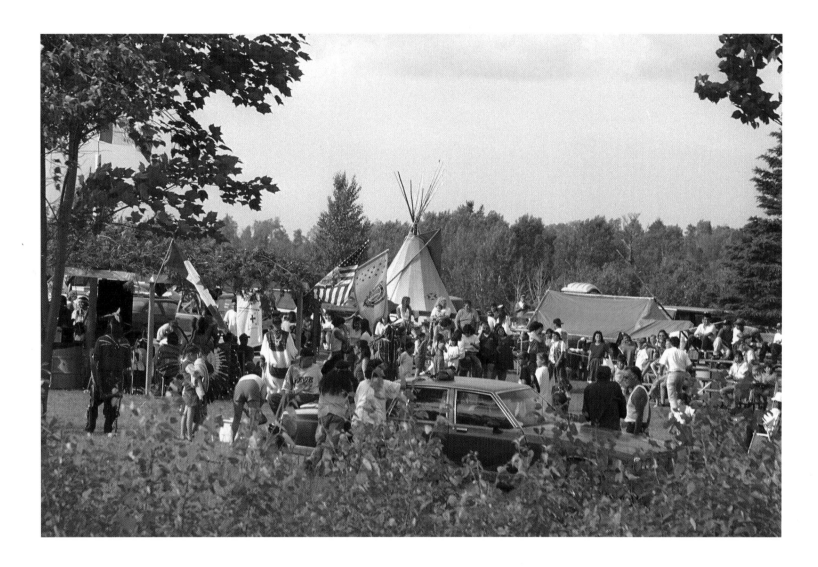

A First Nations powwow at Red Bank.

The 3,000-year-old Mi'kmaq hunting ground at Oxbow, along the Little Southwest Miramichi River.

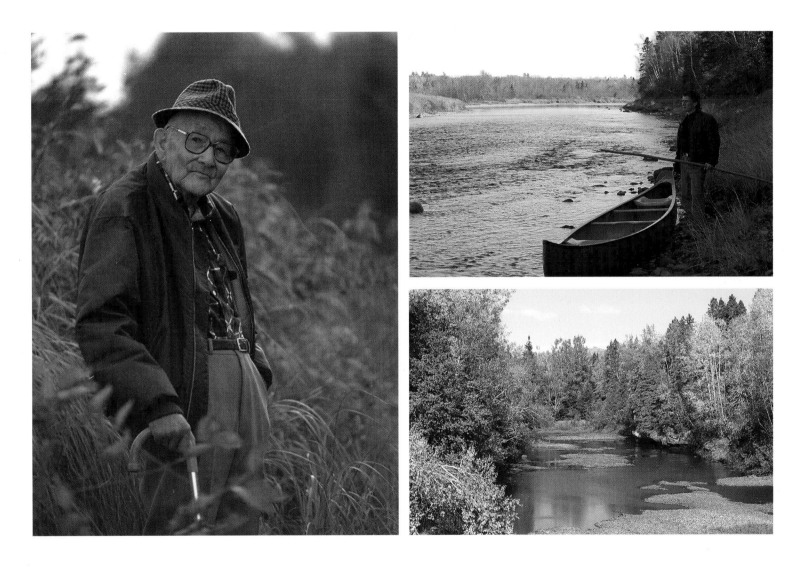

Ancient rites (clockwise from left): Mi'kmaq elder Joe Augustine, who discovered the Oxbow site and the nearby Augustine burial ground; Joe's grandson, Noah Augustine, on the bank of the Little Southwest Miramichi at Metepenagiag, New Brunswick's oldest village; autumn at Whitney.

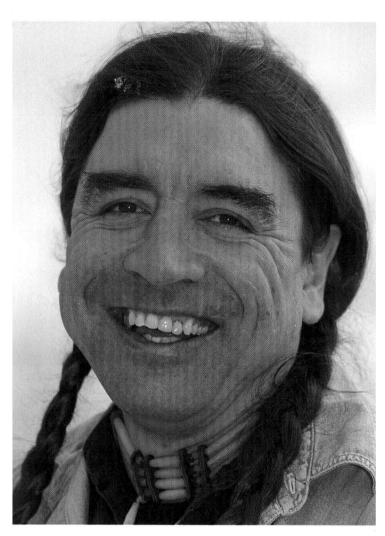
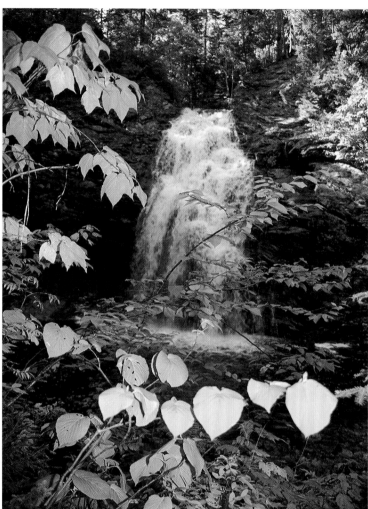

Ivan (Tulley) Paul, founder of the Metepenagiag Mother Earth Lodge (left); Sheephouse Falls (right).

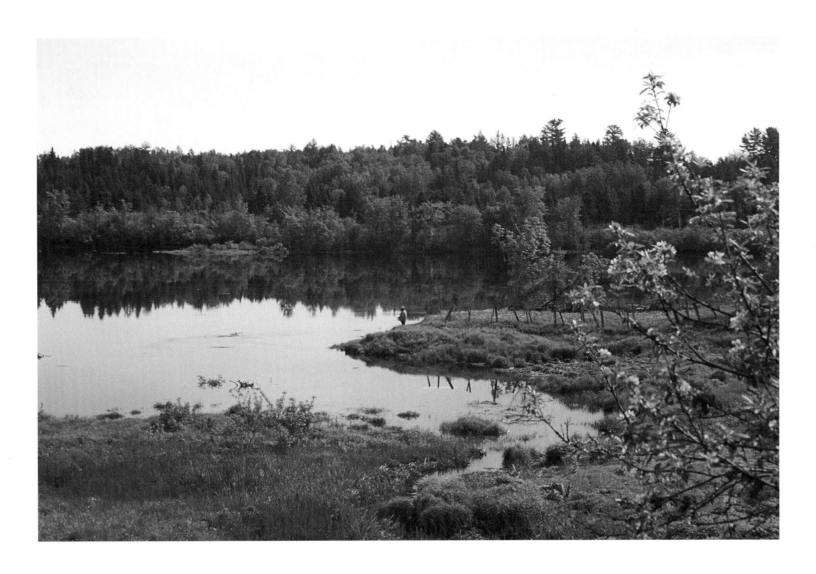

Fishing the Miramichi at Red Bank.

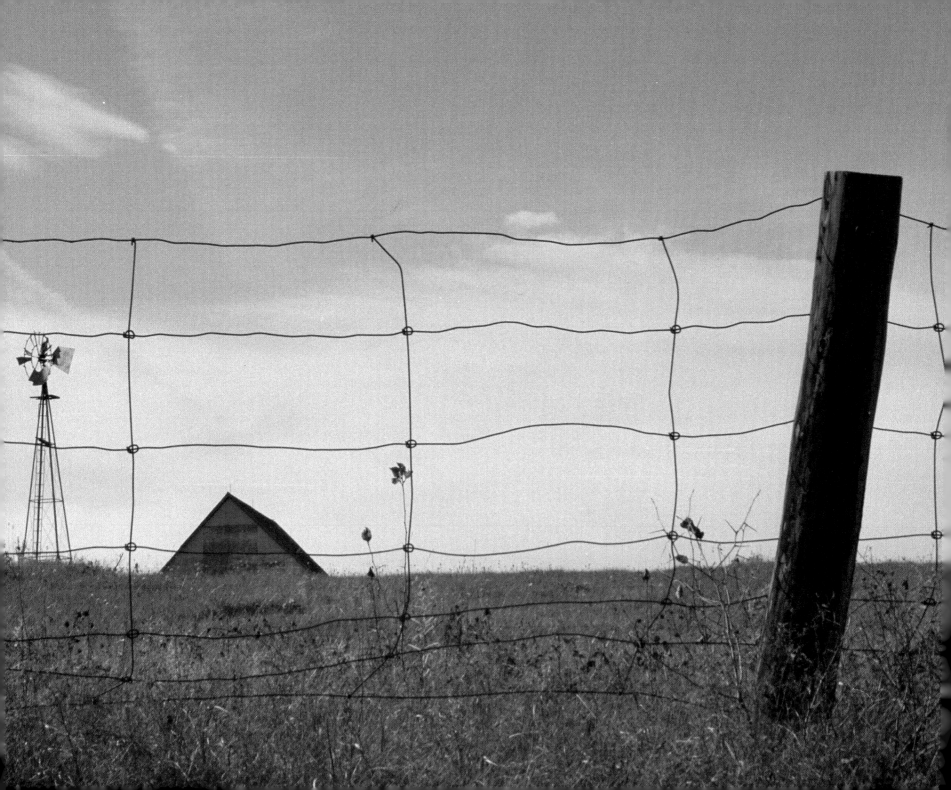

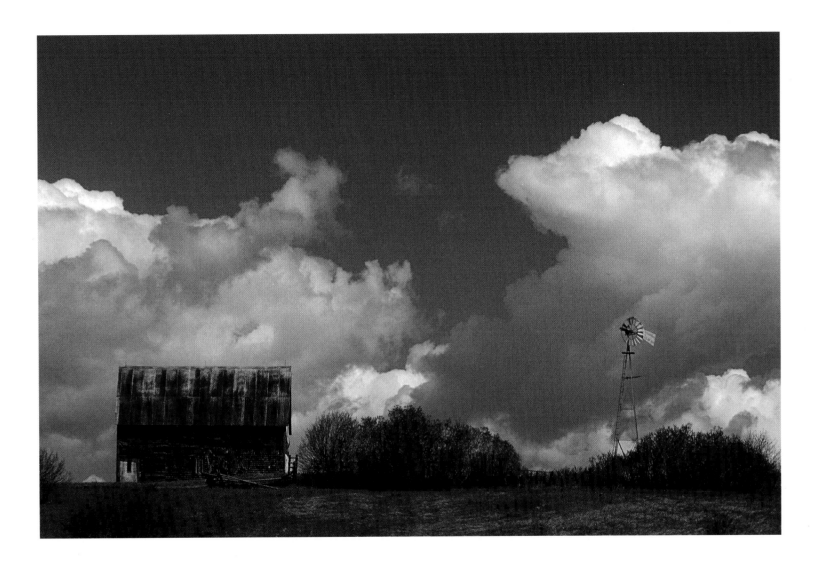

Farmyard details: a windmill (opposite) and a weathervane (above) at Whitney.

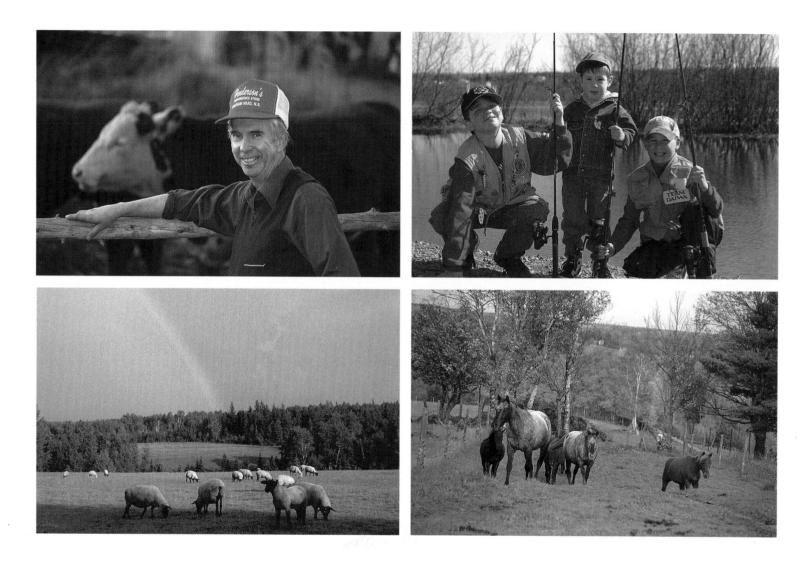

Coexisting (clockwise from top left): Miramichi MP Charles Hubbard with his Hereford cattle at Red Bank; trout-fishing cousins Jordan, Taylor and Ryan Ward of Red Bank; inhabitants of Edgewood Farm at South Esk (bottom right and left).

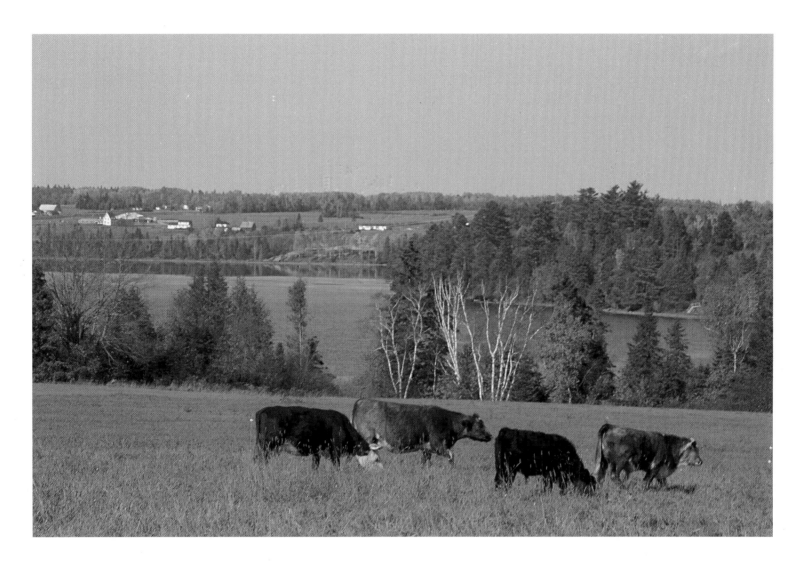

Murray Goodfellow's farm in South Esk.

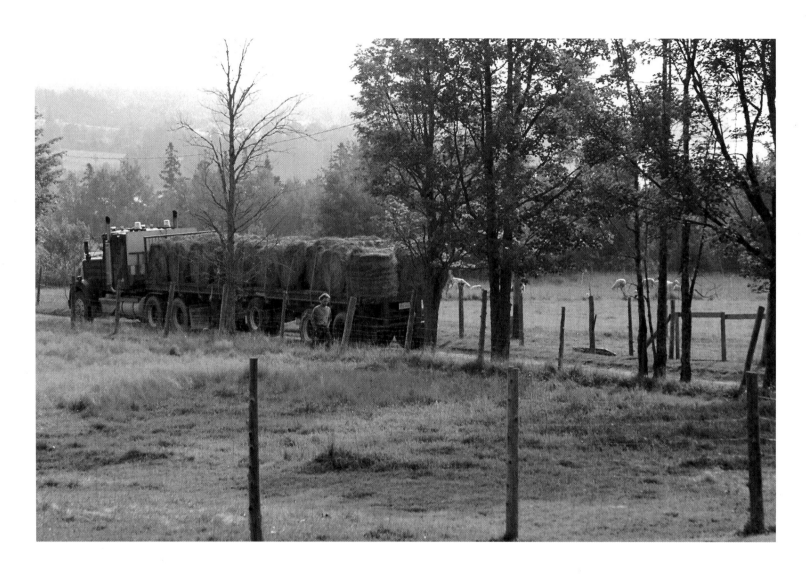

Summer: haying in South Esk.

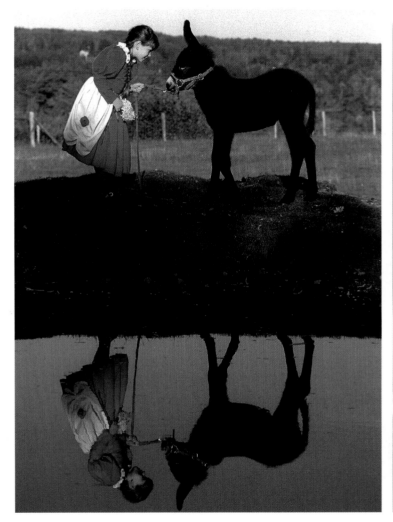
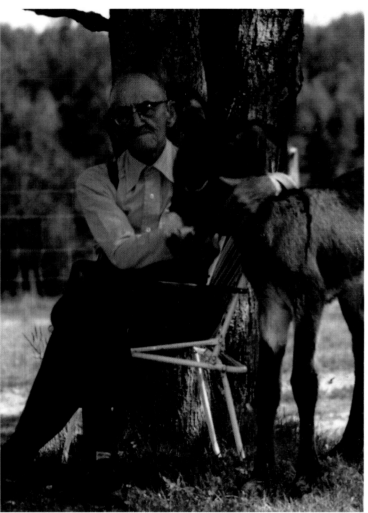

Old friends: Jane MacKenzie has an eye-to-eye talk with burro Molly (left);

Murdock Sutherland Sr. with Lucas.

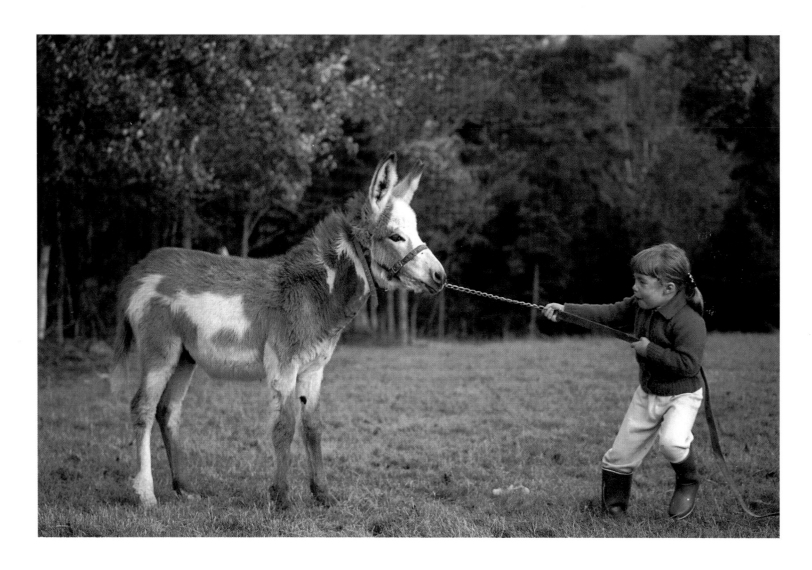

Four-year-old Amanda McAllister of Cassilis with burro Sambo.

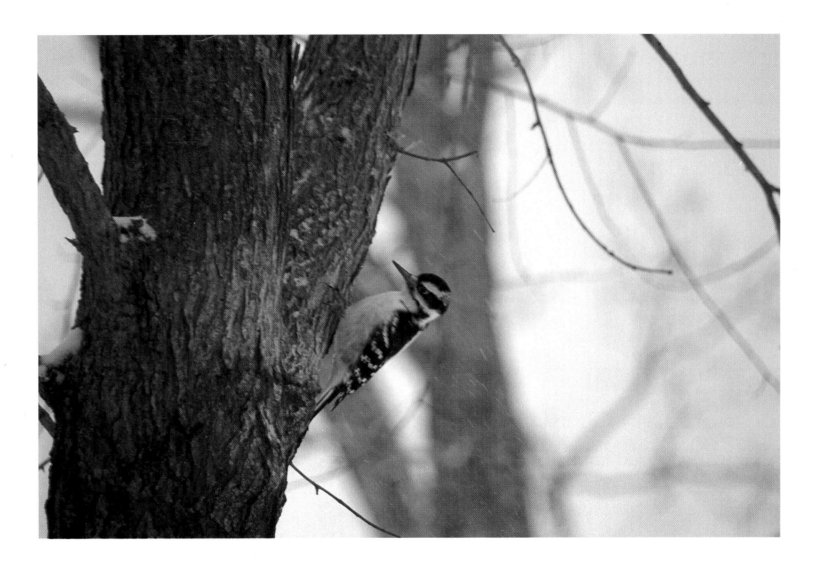

Woodpecker.

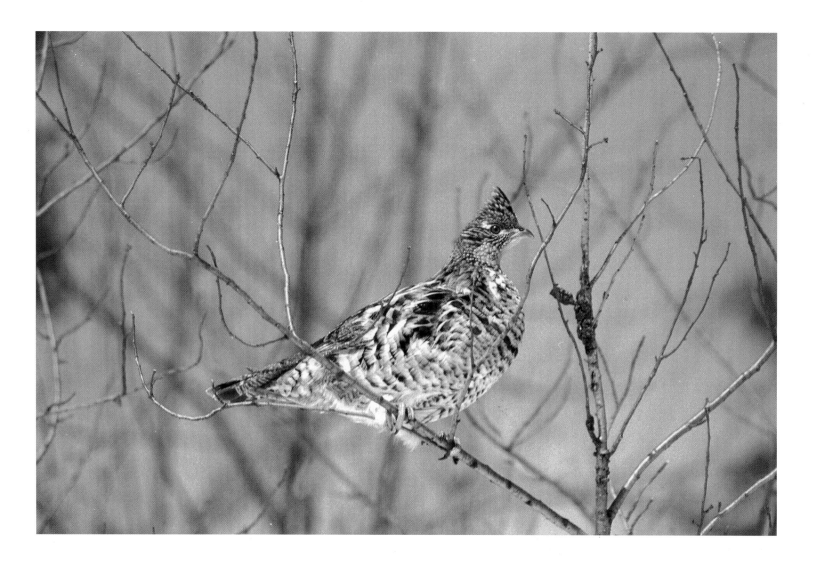

Still untouched: partridge (above), a favourite winter game bird along the Miramichi; pristine snow at South Esk (opposite).

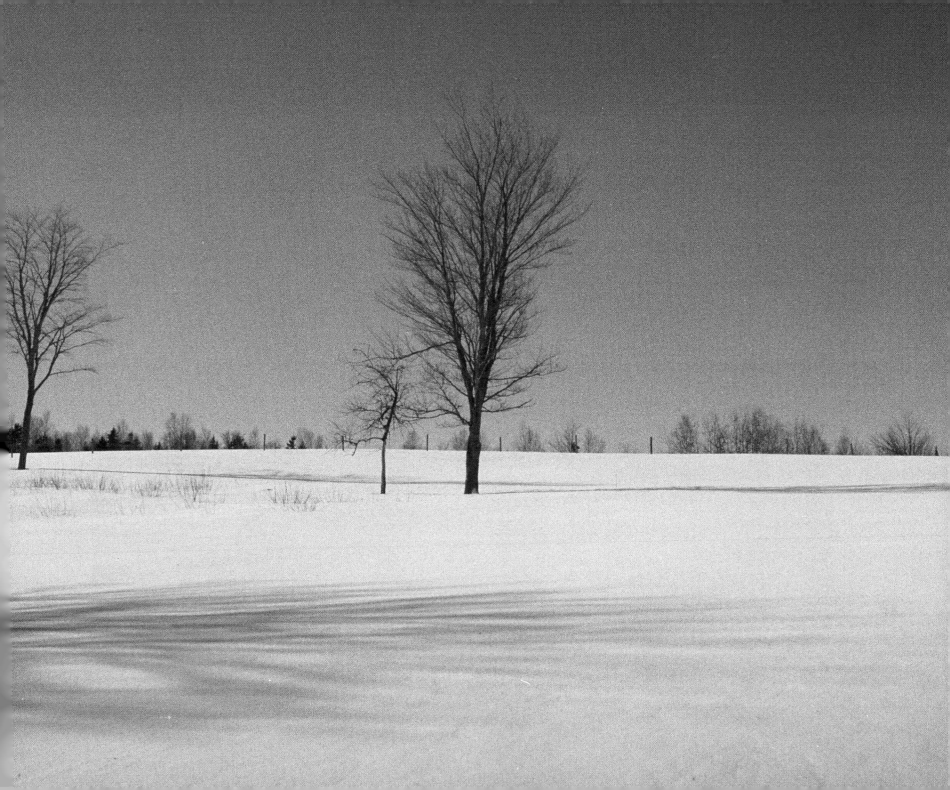

Snowy rails near Sillikers.

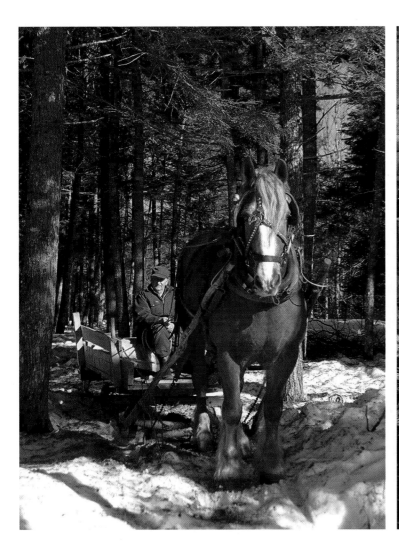

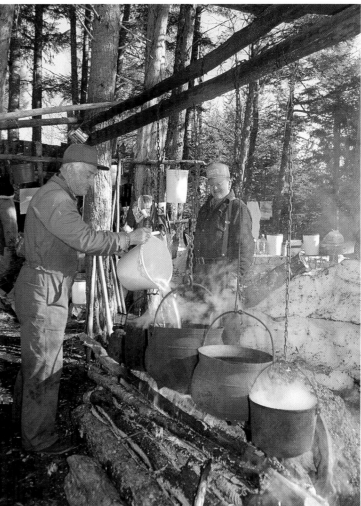

The maple sugar trail (left to right): Elliot Dunnett and friend Bob; Eugene Dunnett (at left) with brother George in Sillikers.

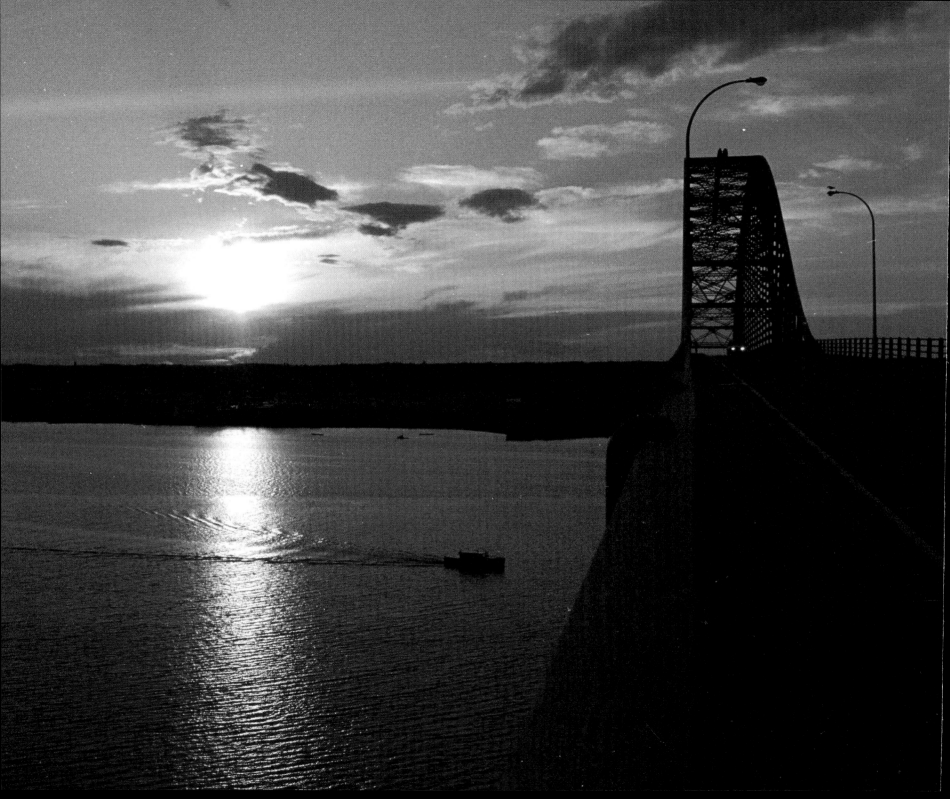

The River and the City

To enter the City of Miramichi is to revel in its festivals, events, fine food and shopping. Here are some of the Miramichi's loveliest buildings and historic sites, such as the 1877 boyhood home of one of our favourite sons: distinguished politician and legendary newspaper baron Lord Beaverbrook. Outside the city, Napan, Black River and Bartibog offer other delights: you can pay tribute to Scotsman Alexander MacDonald and his family at the MacDonald Farm Historic Site, and celebrate the Irish culture of the region at Middle Island.

This is our river, our people, our past, our future.

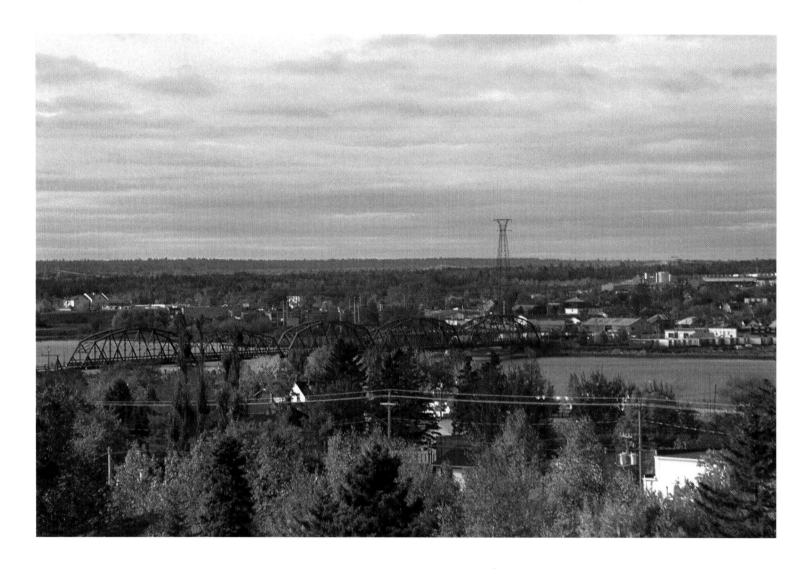

*Two views of Miramichi City West: Morrissy Bridge, as seen from the new Miramichi Regional Hospital (above);
in the heart of the Newcastle business district (opposite).*

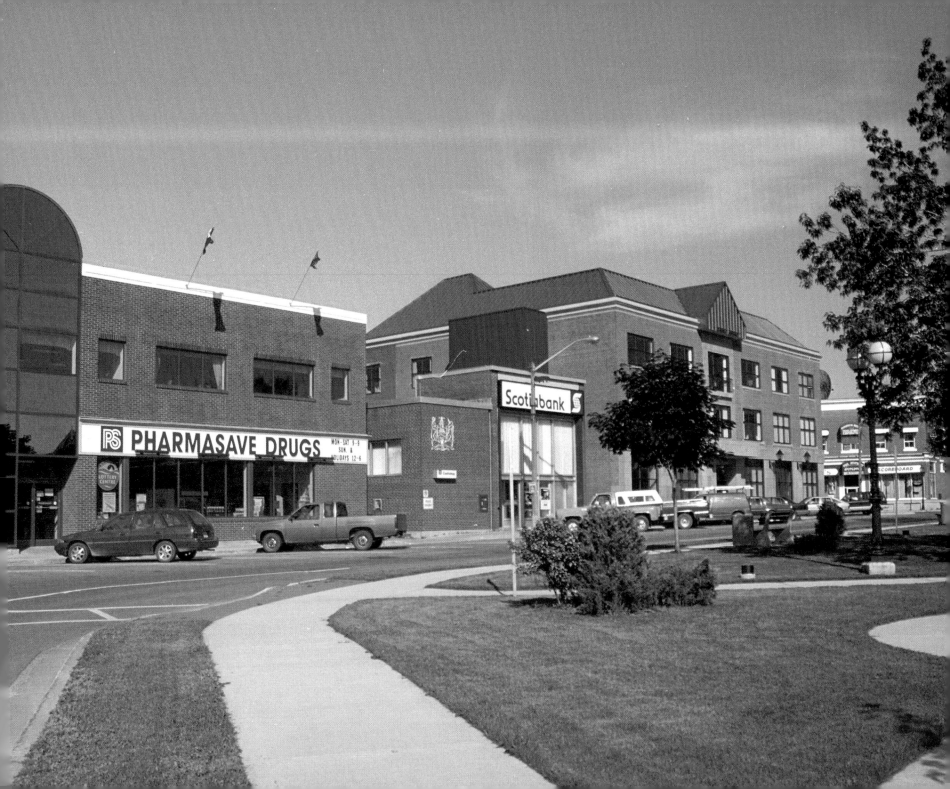

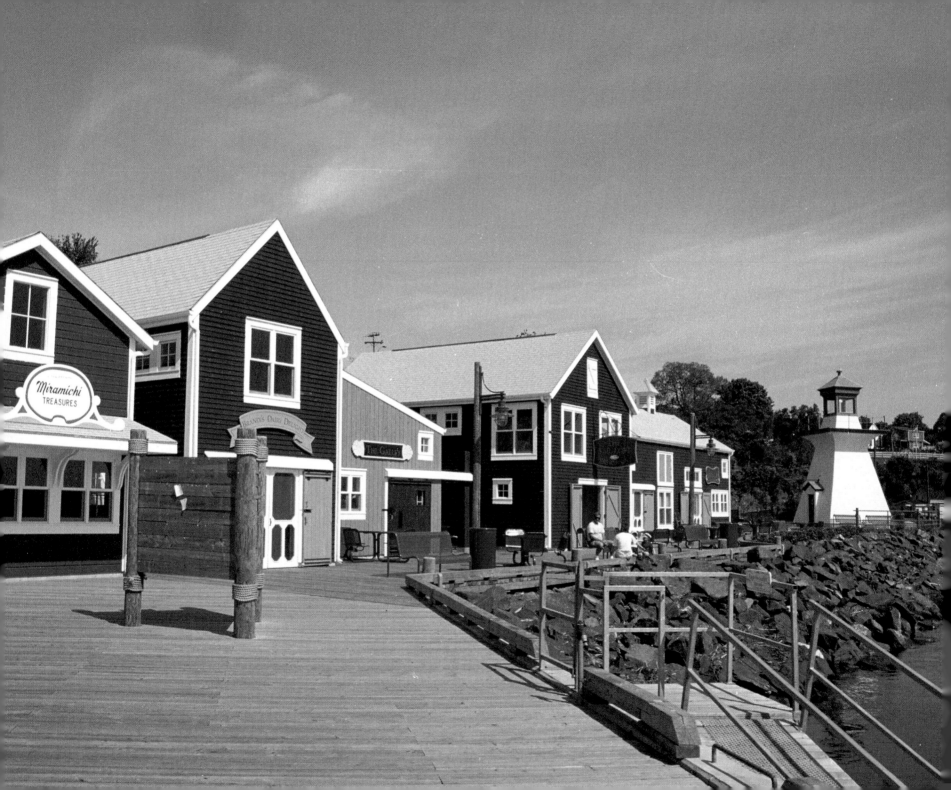

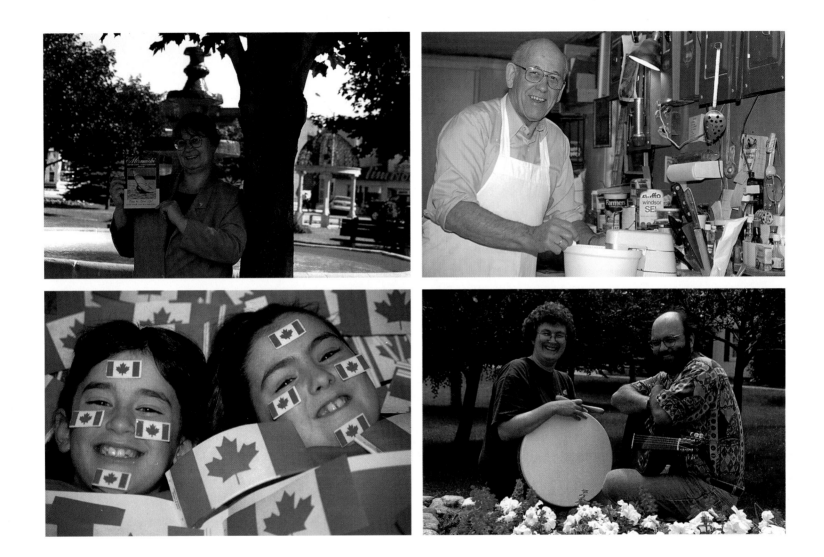

Miramichi City scenes (clockwise from top left): Mayor Janice Morrison; baker U.J. (Jeep) Bosma, at work in his basement; folk musicians Paul McGraw and Connie Doucet; young revellers Whitney Ingraham (at left) and Andrea Prince on Canada Day. The restored waterfront at Ritchie Wharf (opposite).

Miramichi Folksong Festival: Marie Hare, Queen of the Festival; Allan Kelly, King of the Festival.

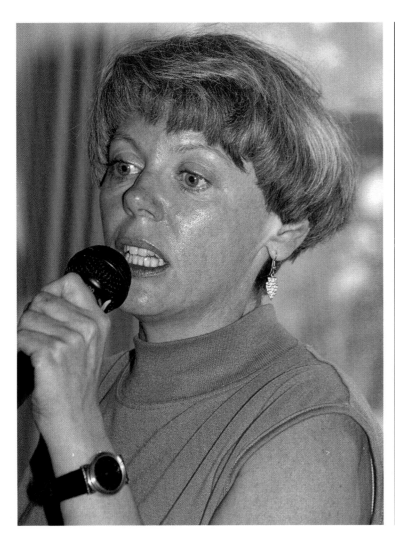 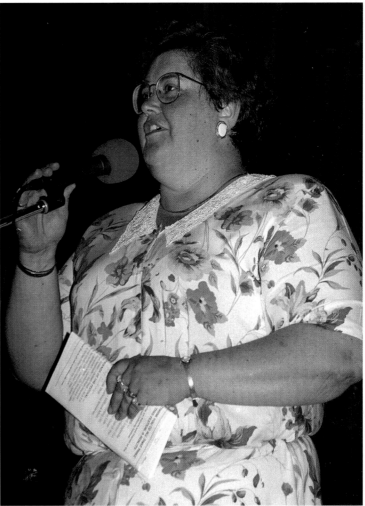

Singing out: Cathy Daigle of Little Bartibog (left); Folksong Festival director Susan Butler of Chaplin Island Road.

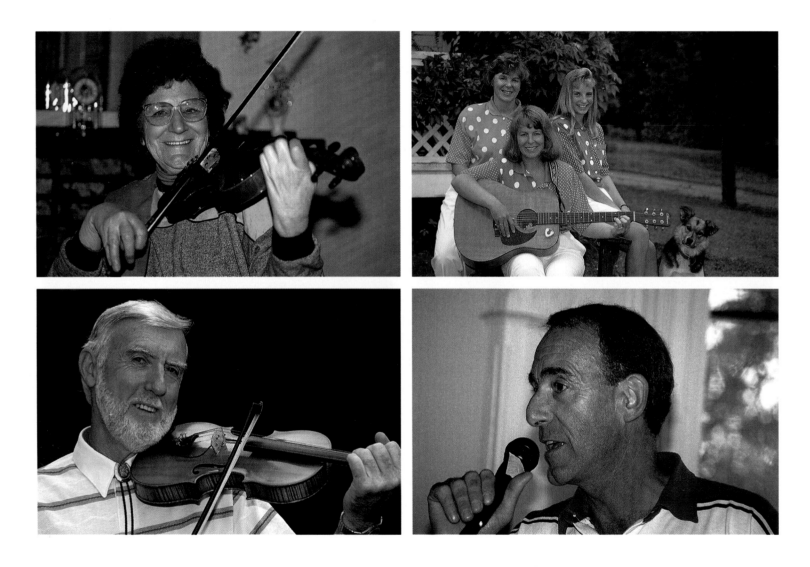

More folk: New Brunswick Hall of Fame fiddlers Matilda Murdoch (top left) and Jim Morrison (bottom left); Lynn Manderson,
Gillian Matchett and Barb Matchett of Red Bank prepare for the festival (top right); singer John Lordon.

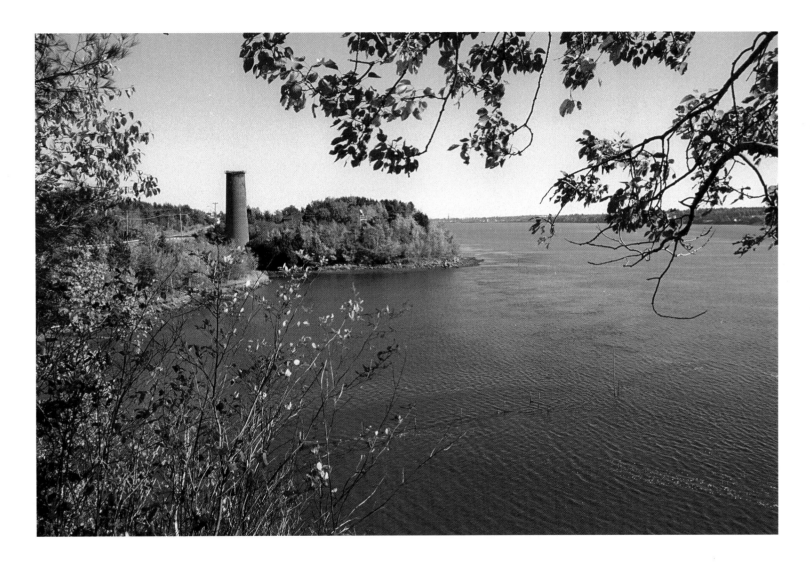

A view of French Fort Cove.

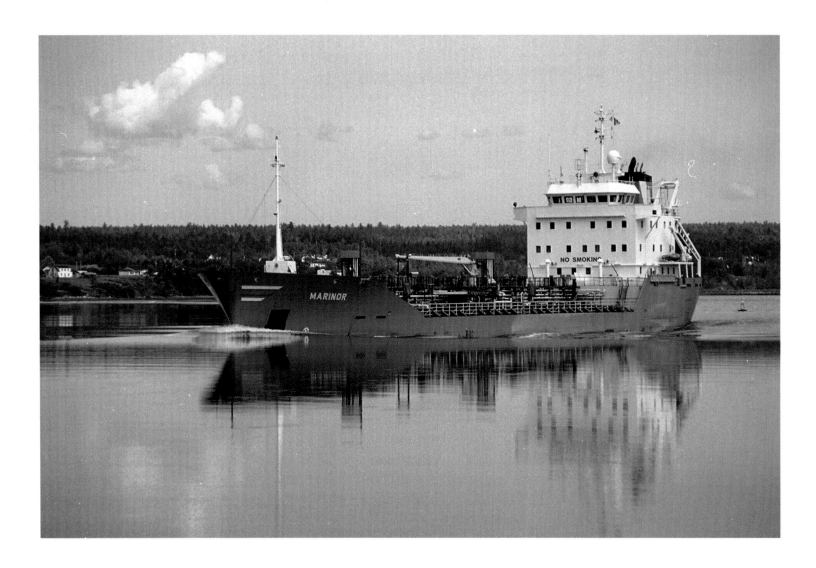

The port: A Marinor ship enters Newcastle harbour.

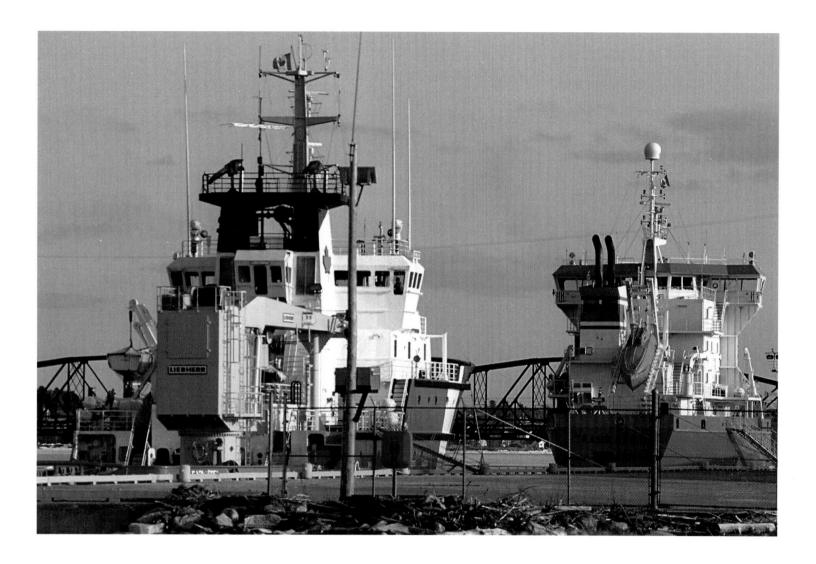

Ships at the Miramichi City dock.

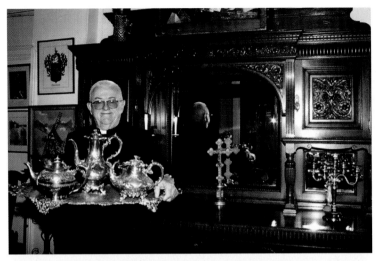

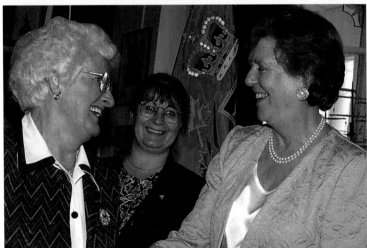

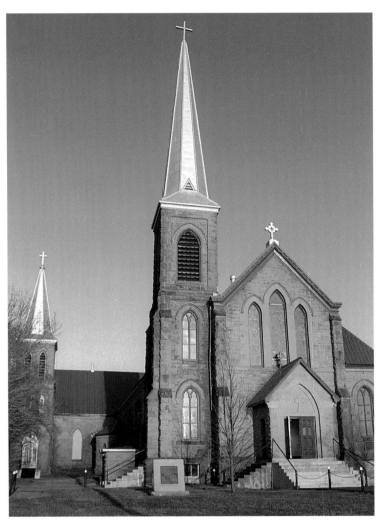

*Pillars of the Nelson-Miramichi area (clockwise from top left): Father Charles Mersereau; St. Patrick's church; Ruth Coughlan
(at left) meets Lieutenant-Governor Margaret Norrie McCain (right) as mayor Janice Morrison looks on. Miramichi Bridge,
which connects Nelson-Miramichi and Newcastle in the new City of Miramichi (opposite).*

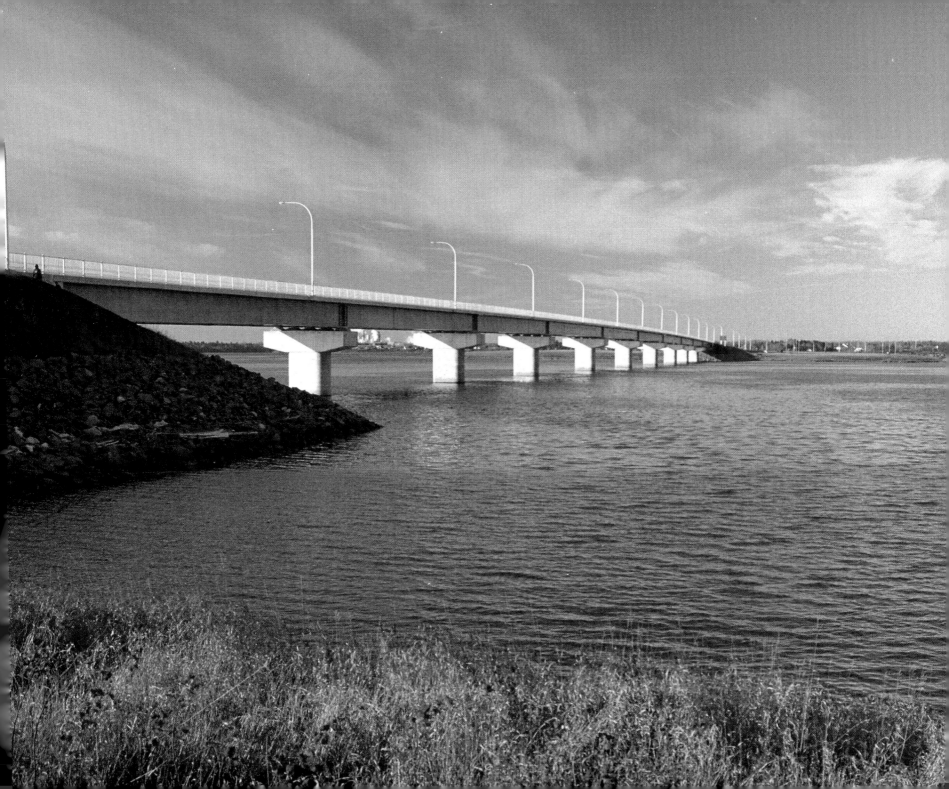

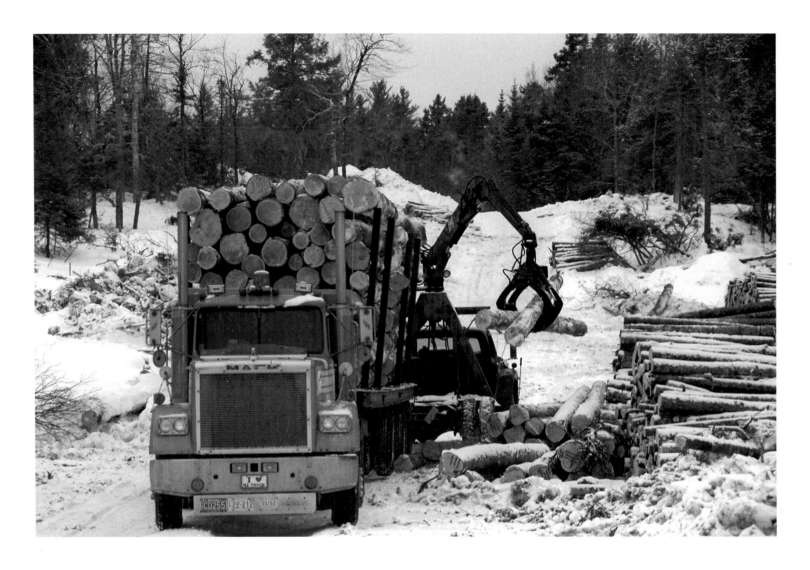

Raw material: Plaster Rock logs destined for the paper mill in Newcastle.

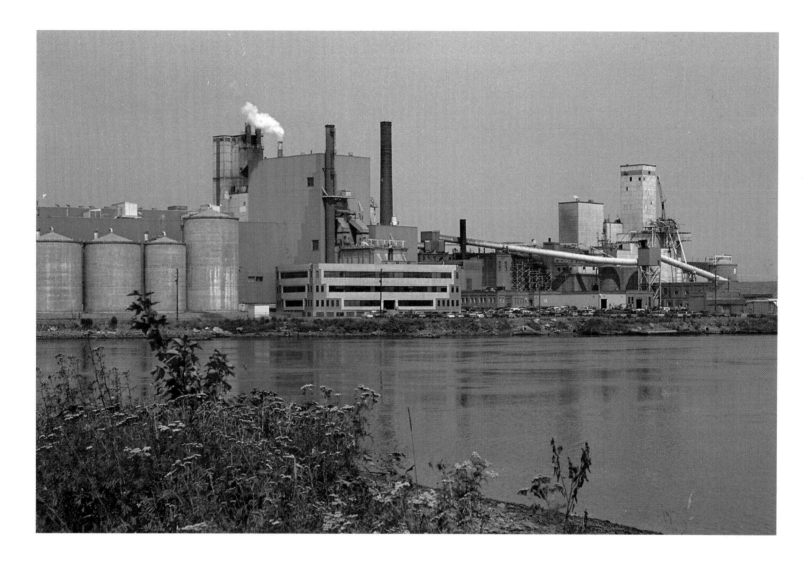

The Repap mill in Newcastle.

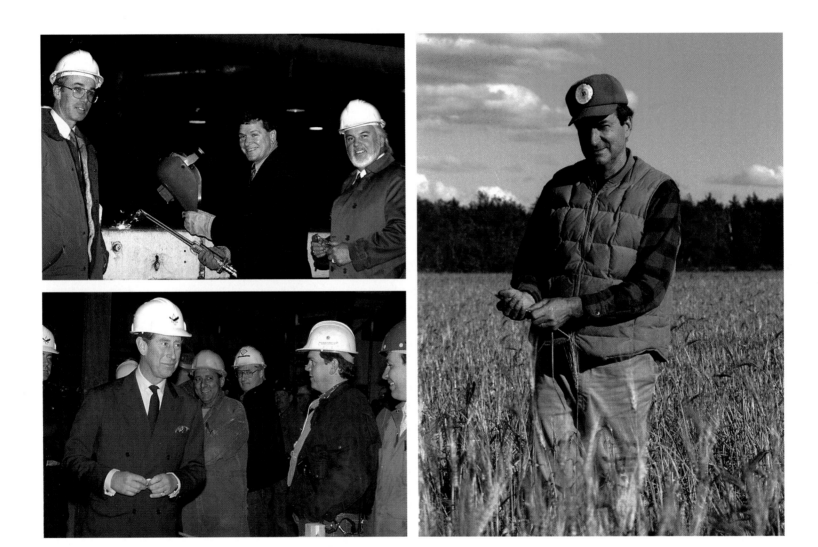

Dawn to dusk (clockwise from top left): Eagle Forest managing director John Godfrey, New Brunswick premier Frank McKenna and Eagle Board Trust chairperson Roger Augustine at the Eagle Forest oriented strand board mill; Douglasfield farmer and environmentalist Ben Baldwin; His Royal Highness Prince Charles greets workers at the Morrison Cove plant. Opposite: sunset at Bushville.

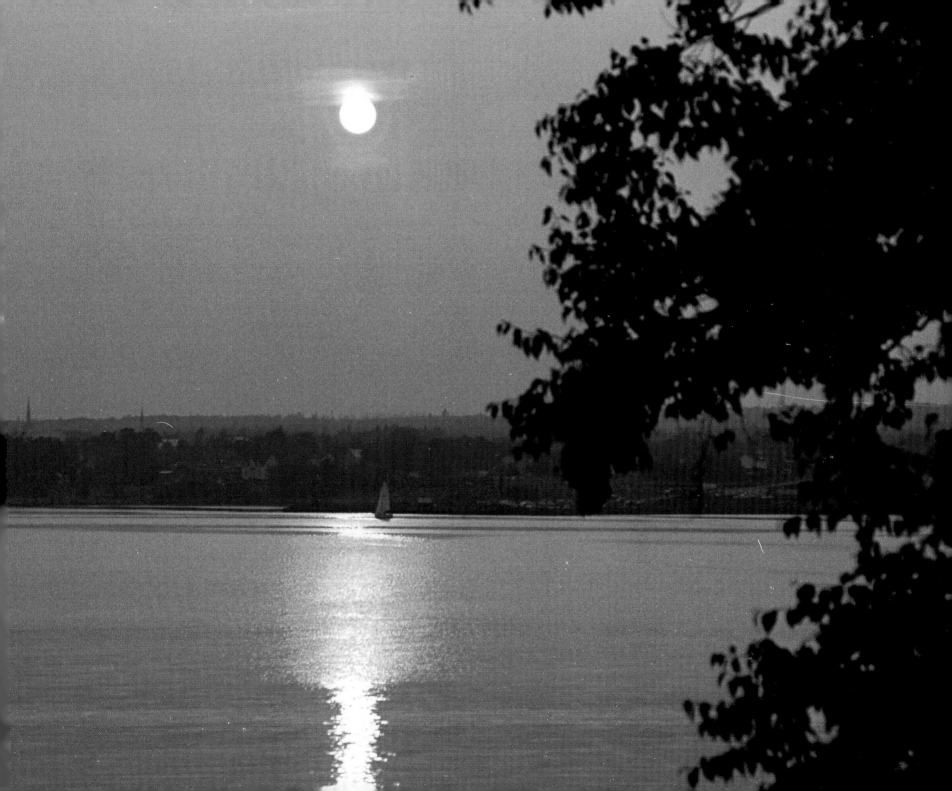

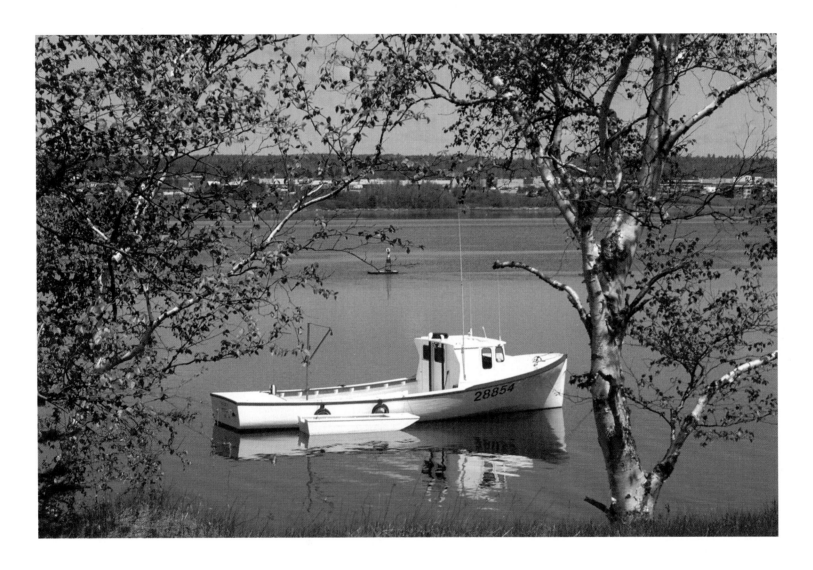

Following the Miramichi South.

A view from across the river of the city's Douglastown area, including St. Samuel's Roman Catholic Church and Seaman's Hospital.

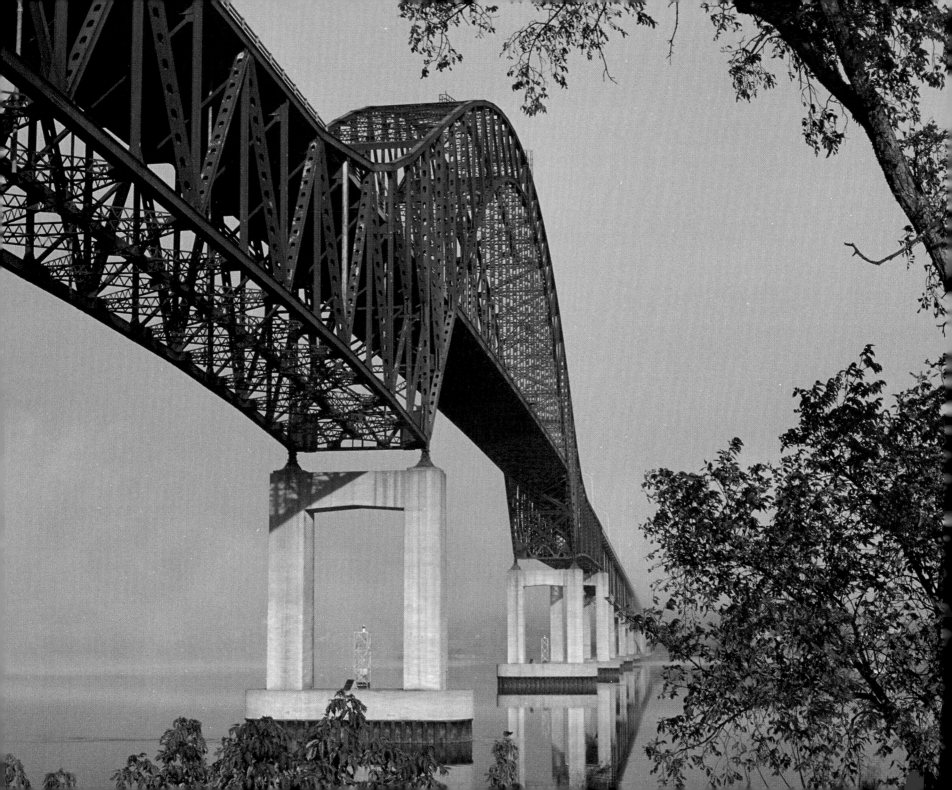

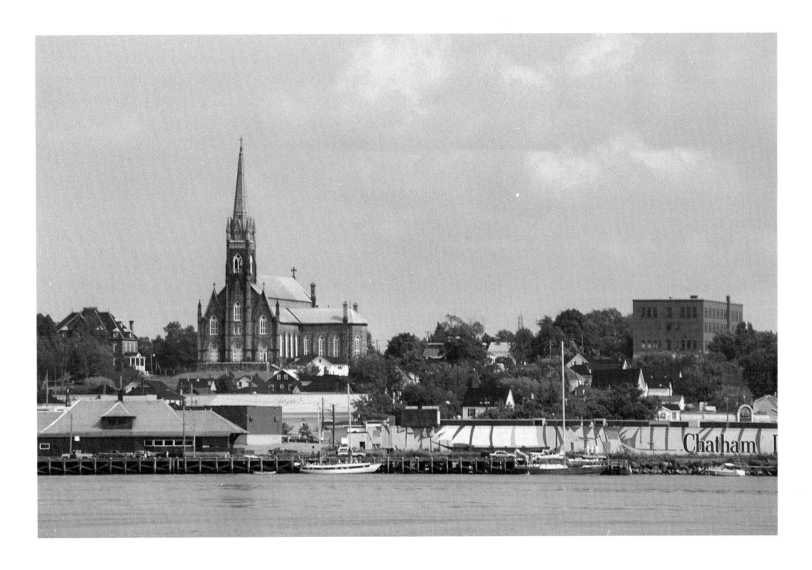

Defining structures: morning fog around Centennial Bridge (opposite); St. Michael's basilica juts against the city's skyline (above).

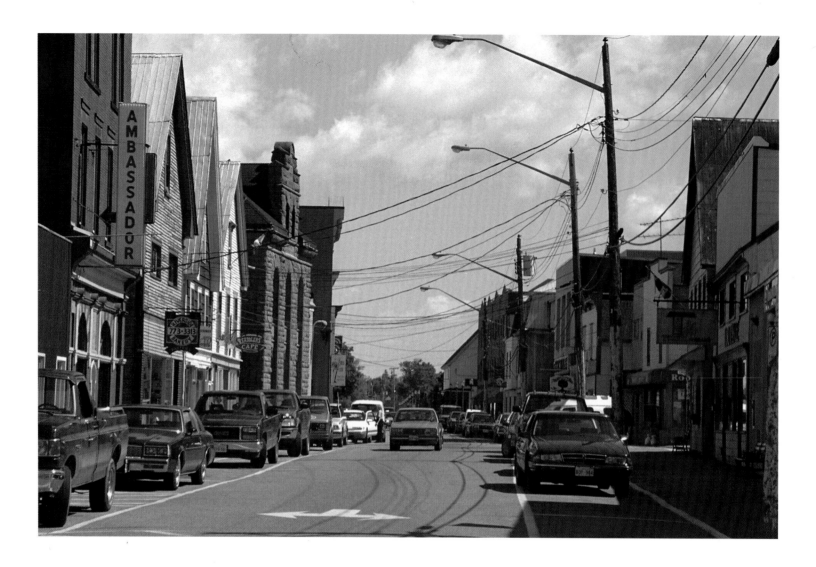

Miramichi City's downtown Chatham area.

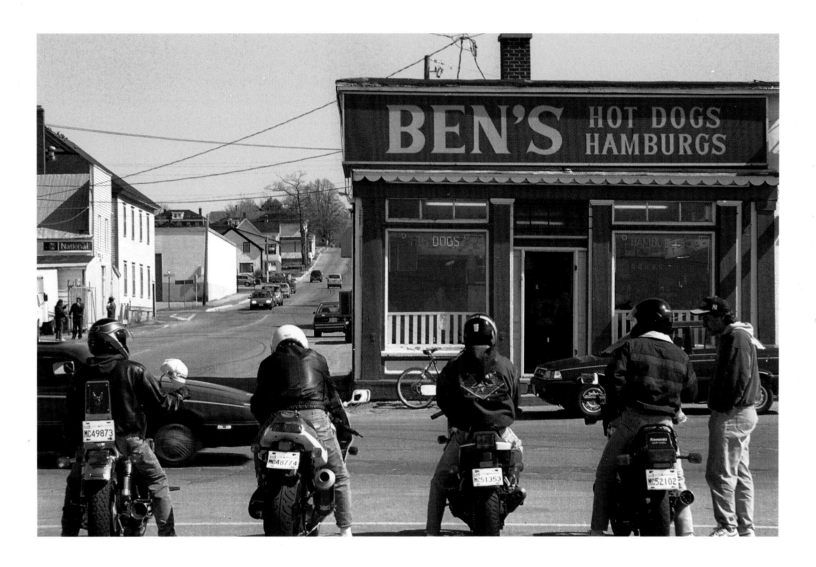

Motorcyclists gather outside Ben's Diner in Chatham area.

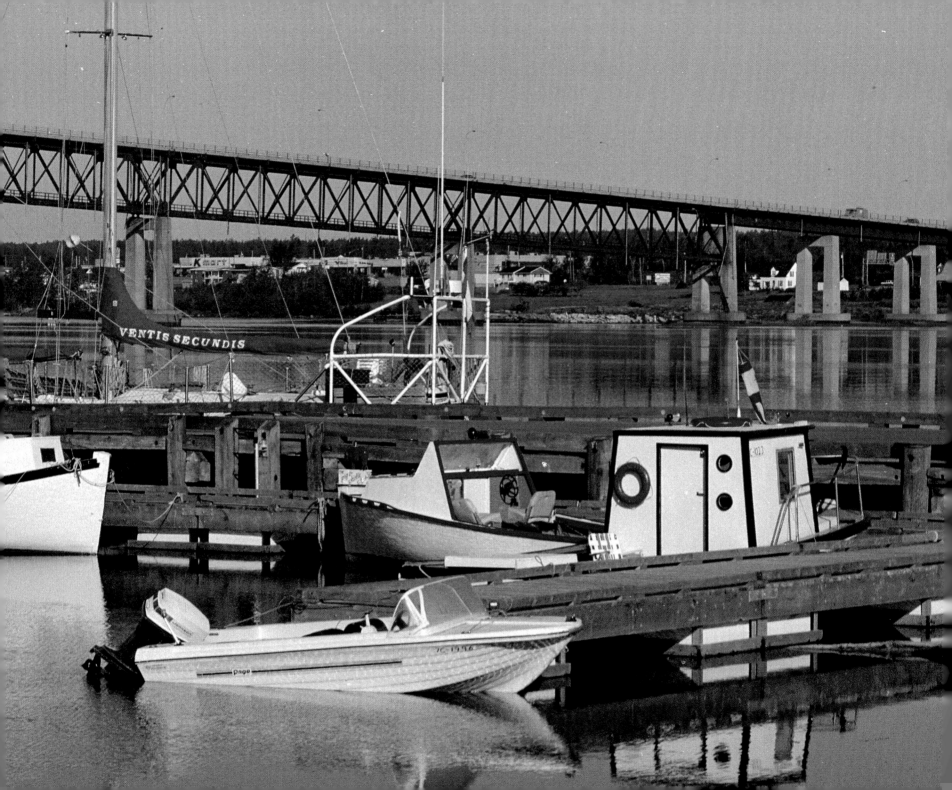

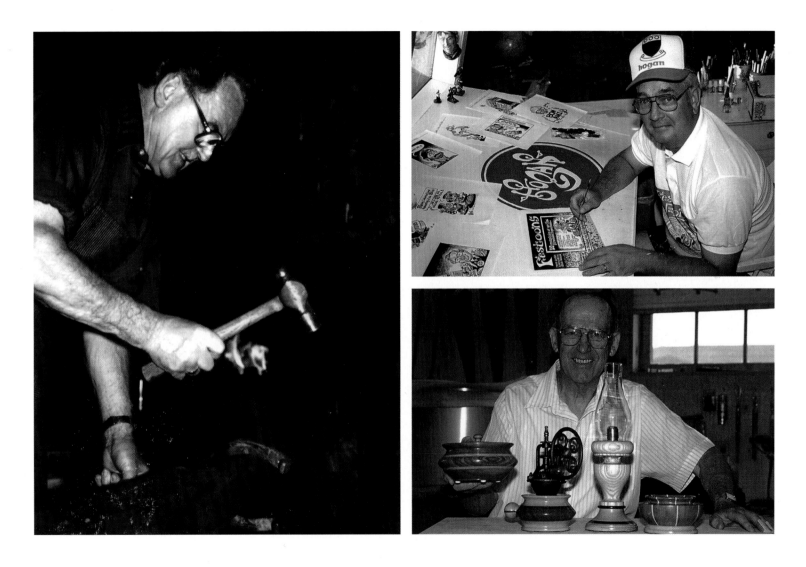

Working in Miramichi City (clockwise from left): blacksmith Jack O'Reilly; award-winning cartoonist Bill Hogan; craftsperson Don Ferguson.
Fishing boats at the old station wharf (opposite).

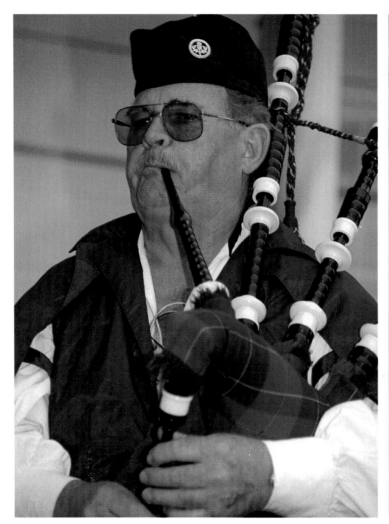 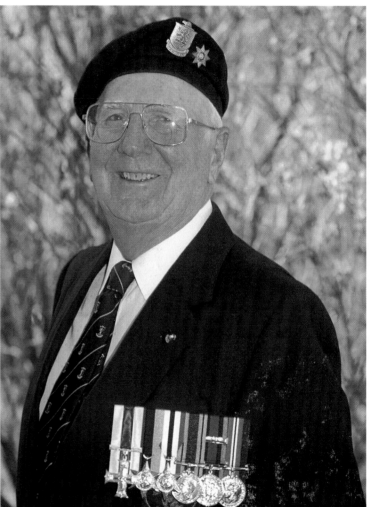

Pride: piper Louis Gallrah (left); Leonard Bowman Robertson wears his military cross for gallantry, awarded in 1945 (right).

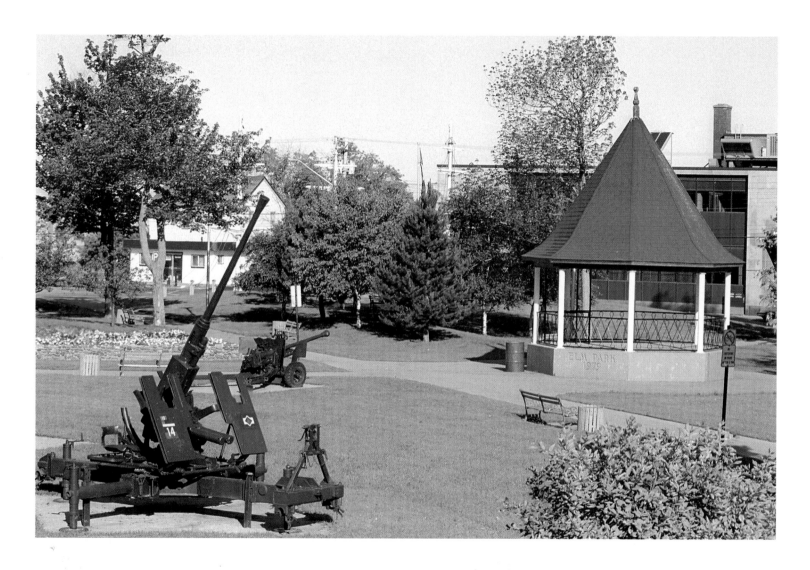

Elm Park in Chatham area of the city.

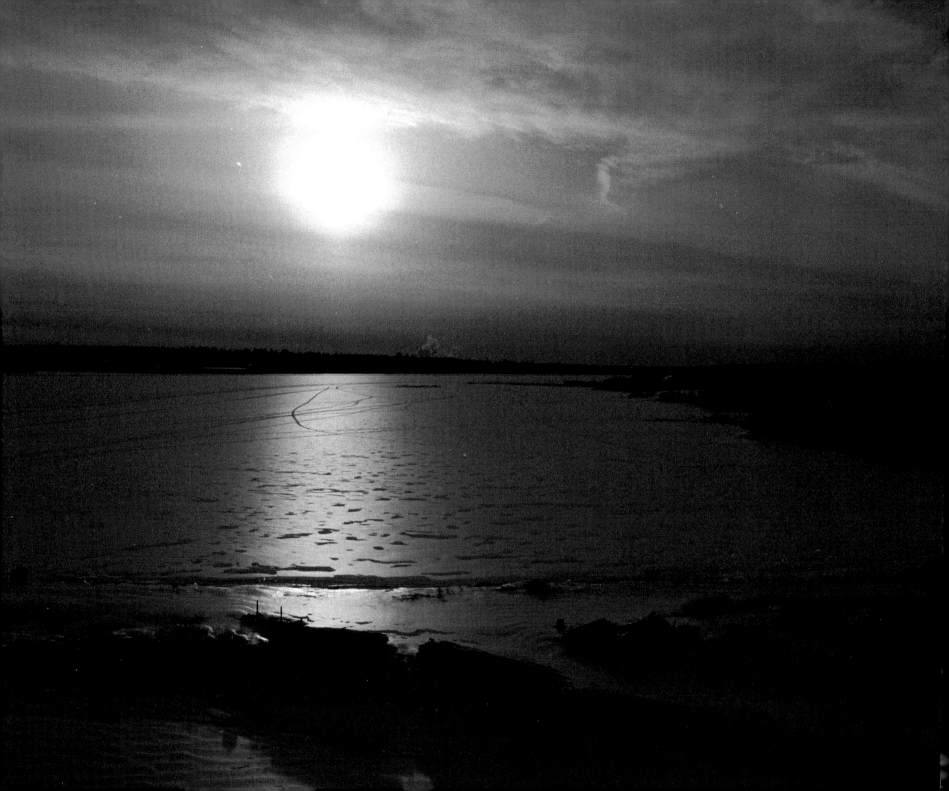

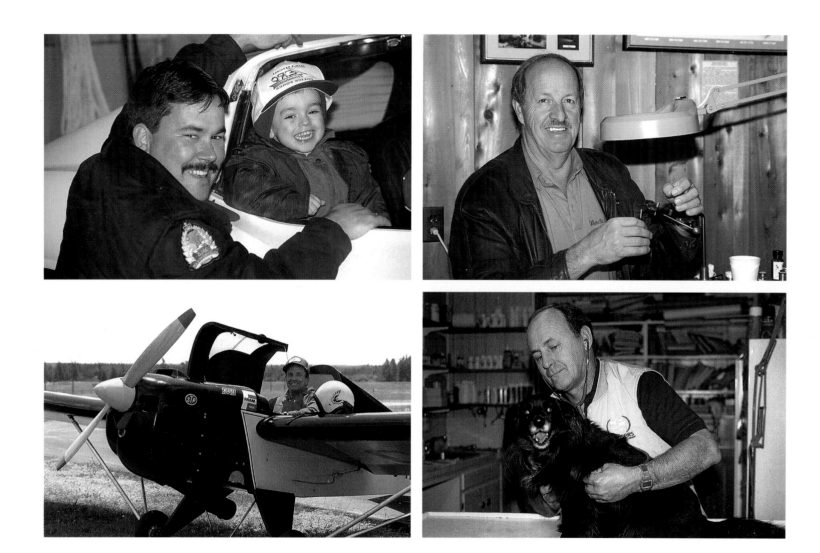

Familiar faces (clockwise from top left): Christopher Knowles takes the driver's seat in constable Arthur McLean's police vehicle; fly-tier Budd Kitchen; pilot Jerry McLean; veterinarian Guy Sorel. Opposite: Sunset from Centennial Bridge.

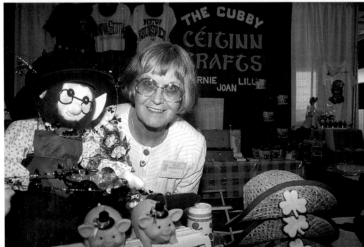

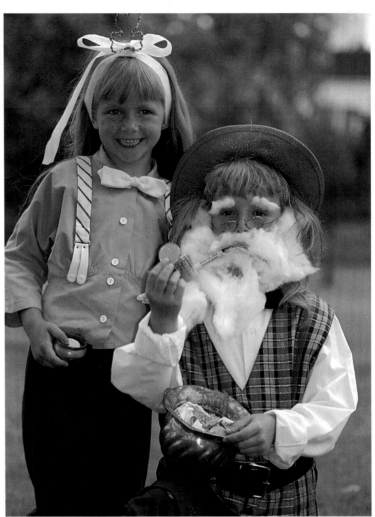

Miramichi City's Irish Festival (clockwise from top left): Celebrants include Premier Frank McKenna, Hal Roach, Eily O'Grady and Frank Patterson;
Michella Soppa (at left) and her sister Danielle; community activist Lillian Barry displays her craft. Opposite: St. Michael's basilica.

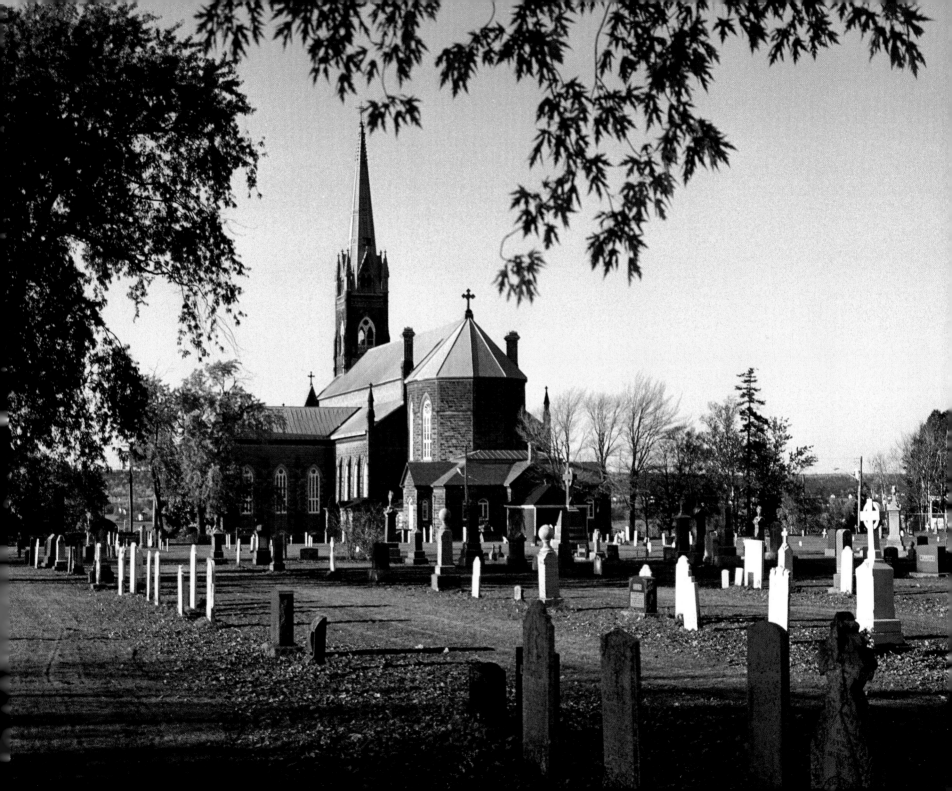

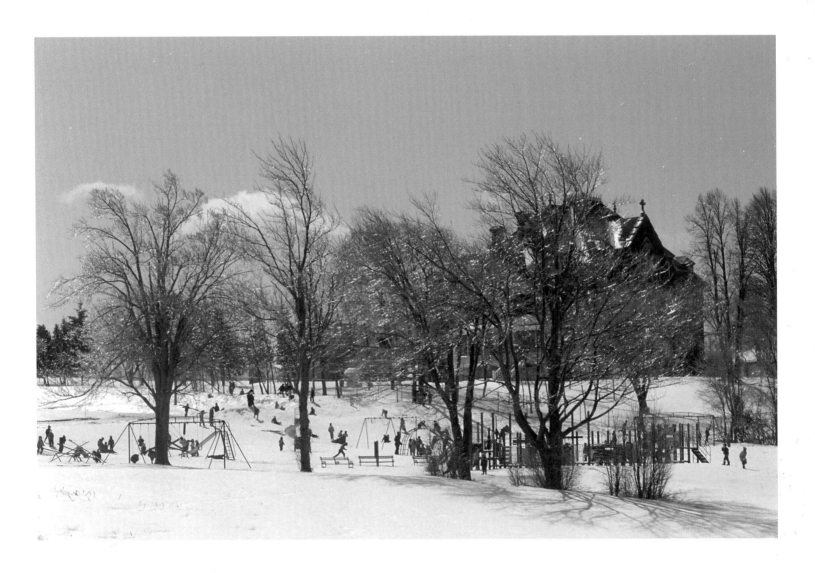

Winter at Ian Baillie School playground in Chatham area.

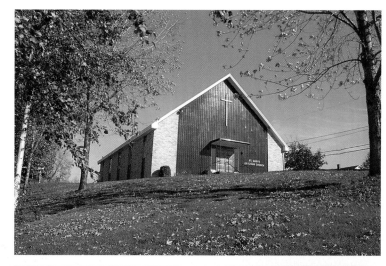

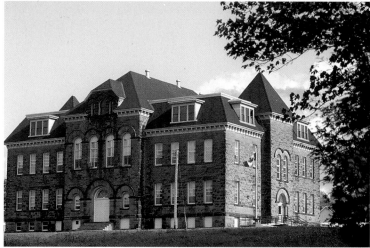

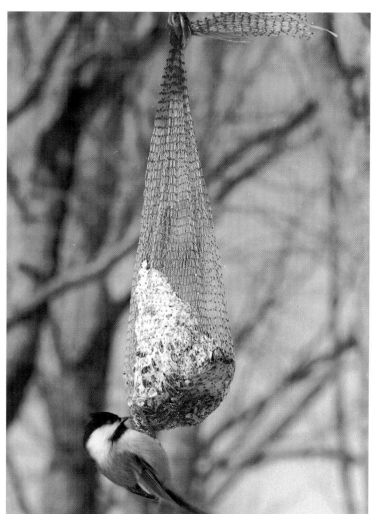

Chatham area meeting-places (clockwise from top left): St. Mary's Anglican church; a chickadee feeder; District 16 school board office.

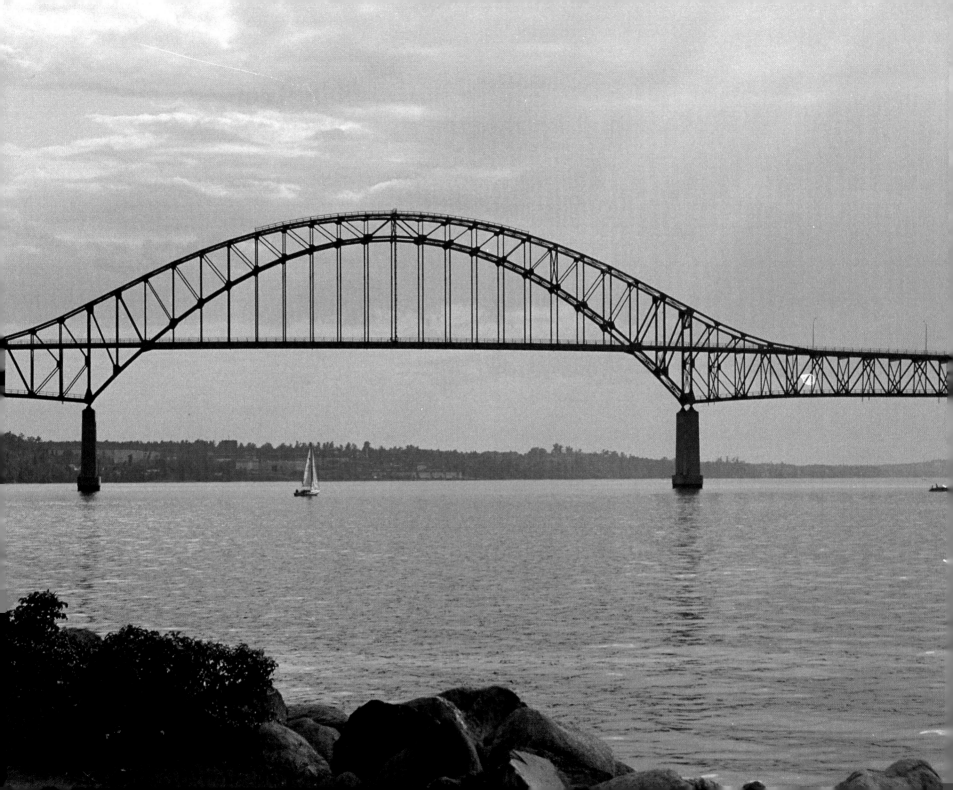

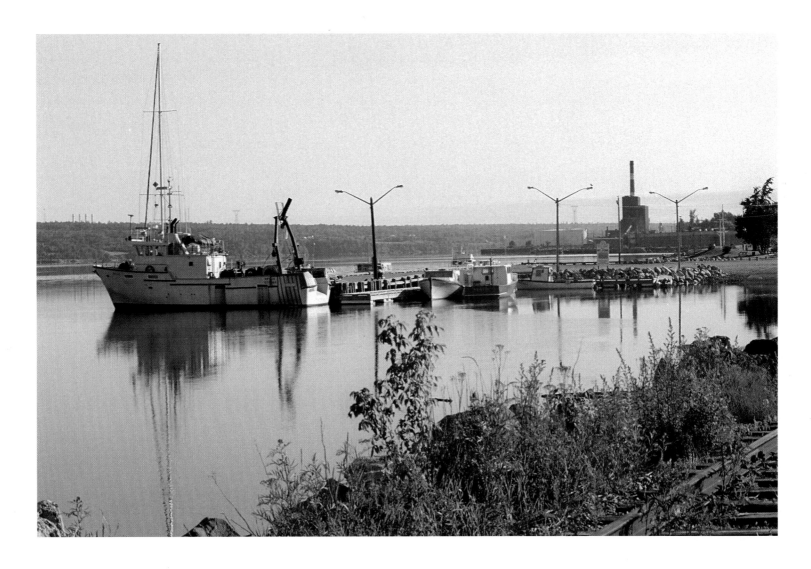

Scenic river: sailing past Centennial Bridge (opposite); Chatham area waterfront and the old station wharf, with the New Brunswick Power generating station in the background (above).

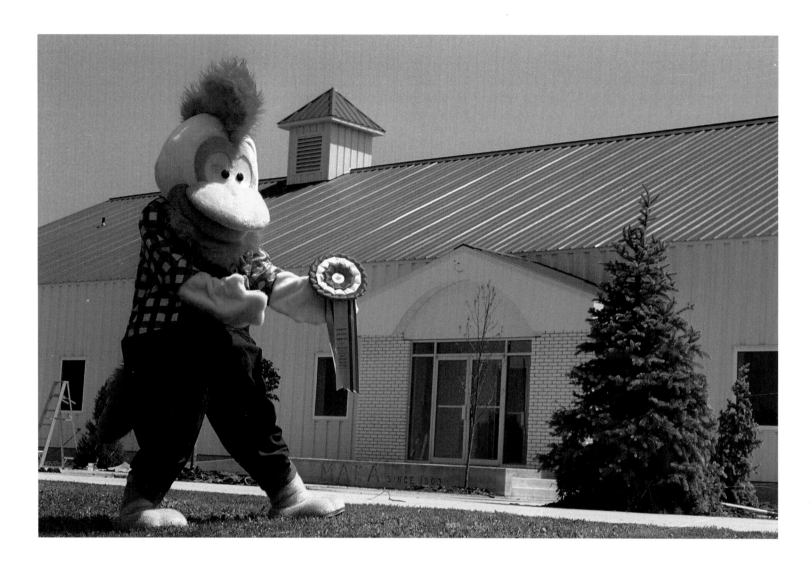

Rex the Rooster, mascot of the city's annual Miramichi Agricultural Exhibition.

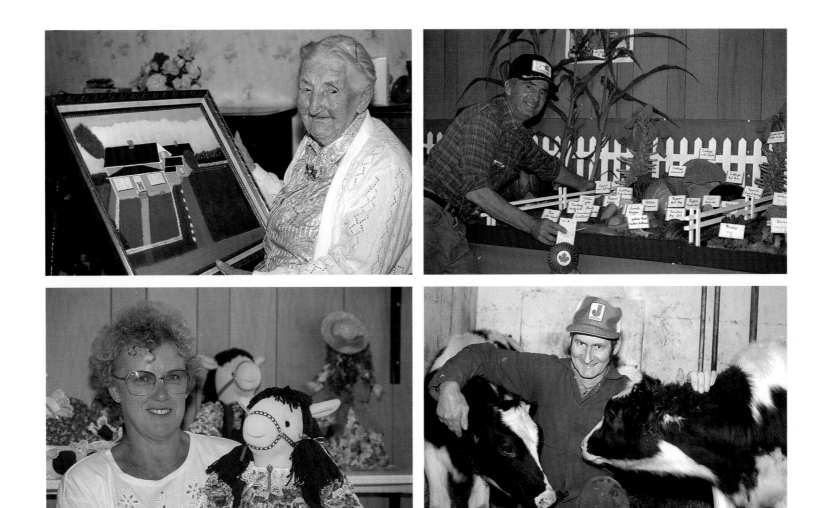

Showcase (clockwise from top left): Katie Knowles of England's Hollow holds onto a painting of her longtime home; Peter Losier of Napan with award-winning vegetables; Dairy farmer Donald Newton of Black River; Doris Bremner of Napan with her handiwork at the Napan Agricultural Show.

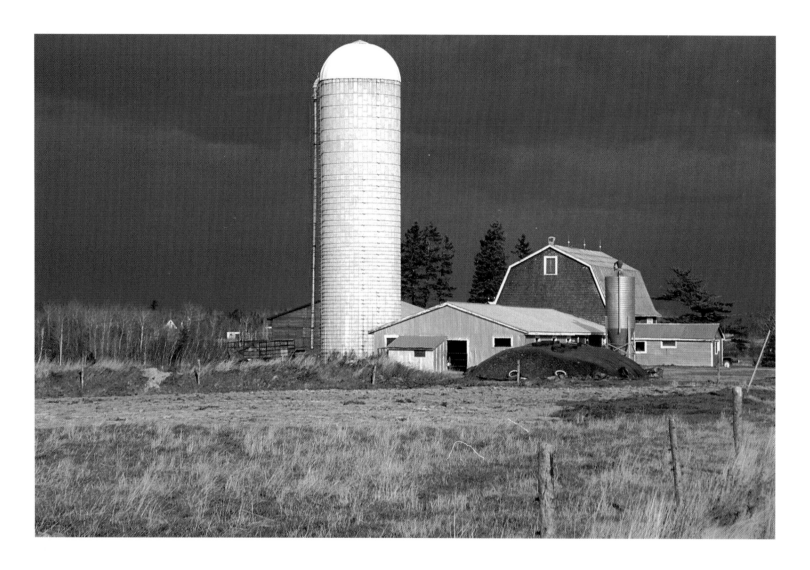

Dix-n-Dale farm in Napan, just outside the Miramichi City limits.

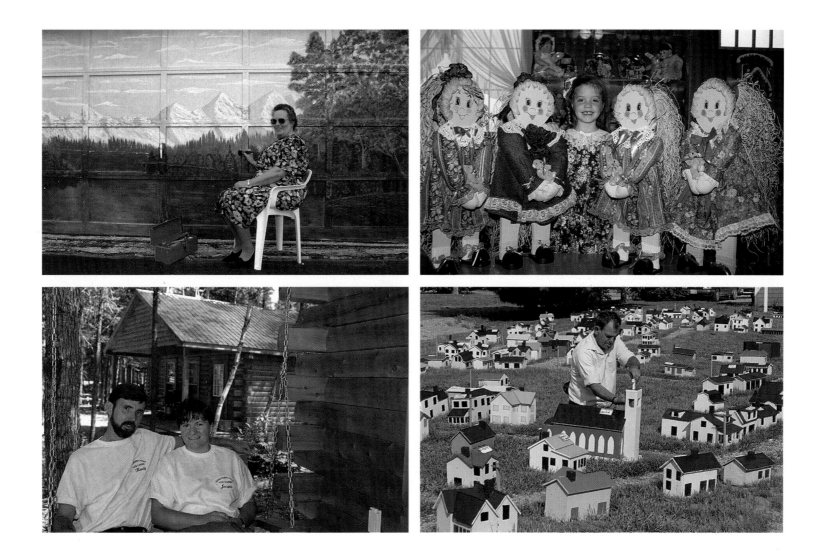

Pastimes (clockwise from top left): Shirley Merritt of North Napan paints a mural on the family garage;
Stephanie MacDiarmid of Napan poses with raffia dolls made by her mother, Karen; Lester Savoy of Loggieville and his miniatures of the
community; Randy and Jacquie Murdoch, owners of Schooner Point Log Cabins in North Napan.

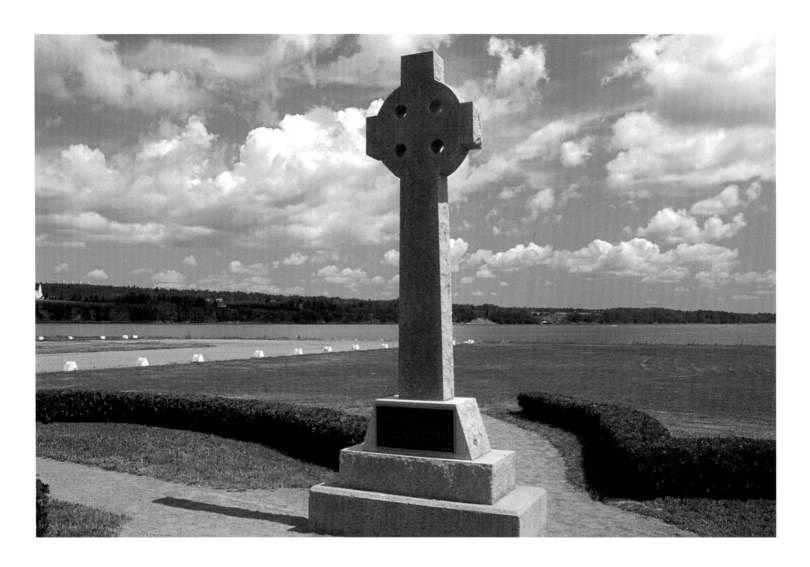

Celtic Cross at Middle Island.

Shore Road Beach.

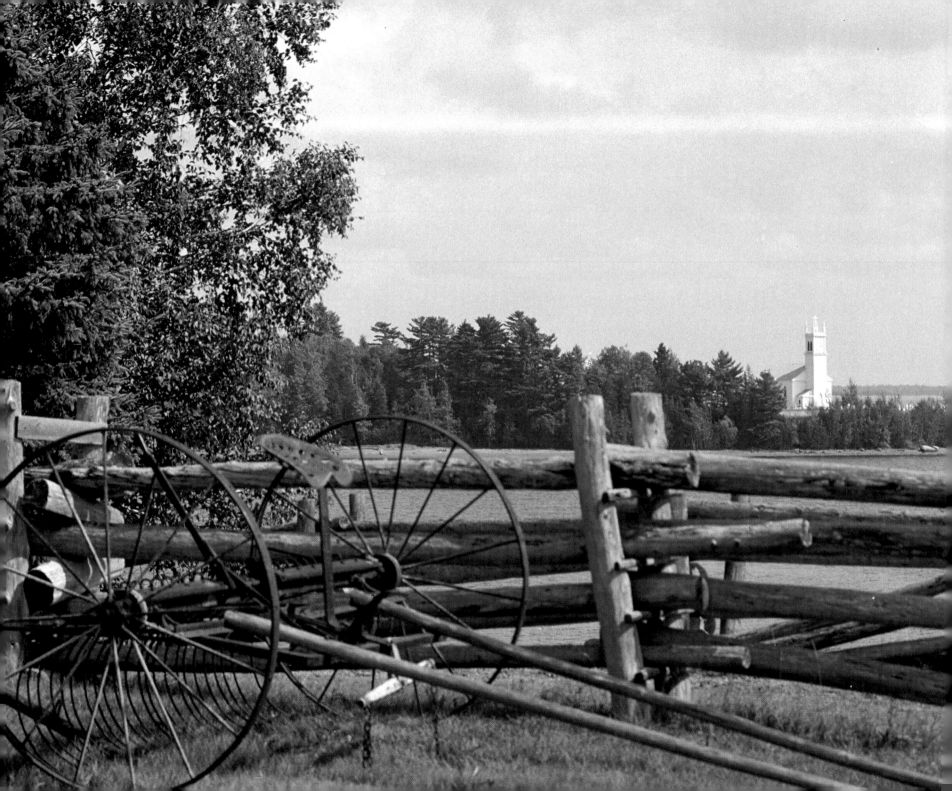

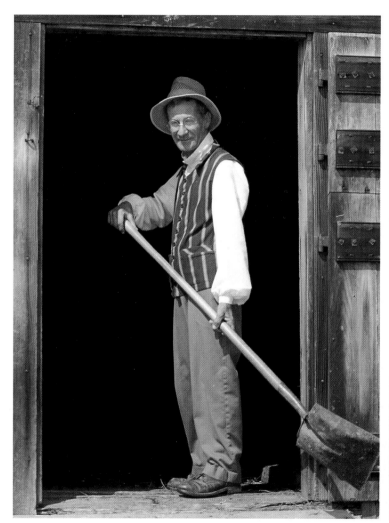

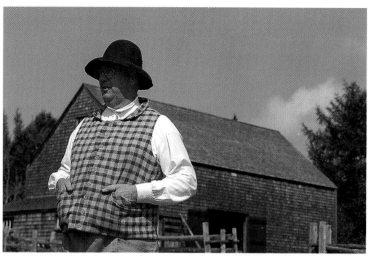

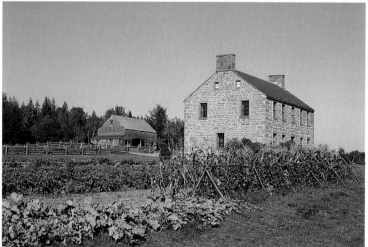

MacDonald Farm Historic Site at Bartibog (clockwise from left): former assistant supervisor Leandre (Leo) Girouard; supervisor H. Blair Carter; the farmhouse. Opposite: Sts. Peter and Paul Church in Bartibog, as seen from MacDonald Farm.

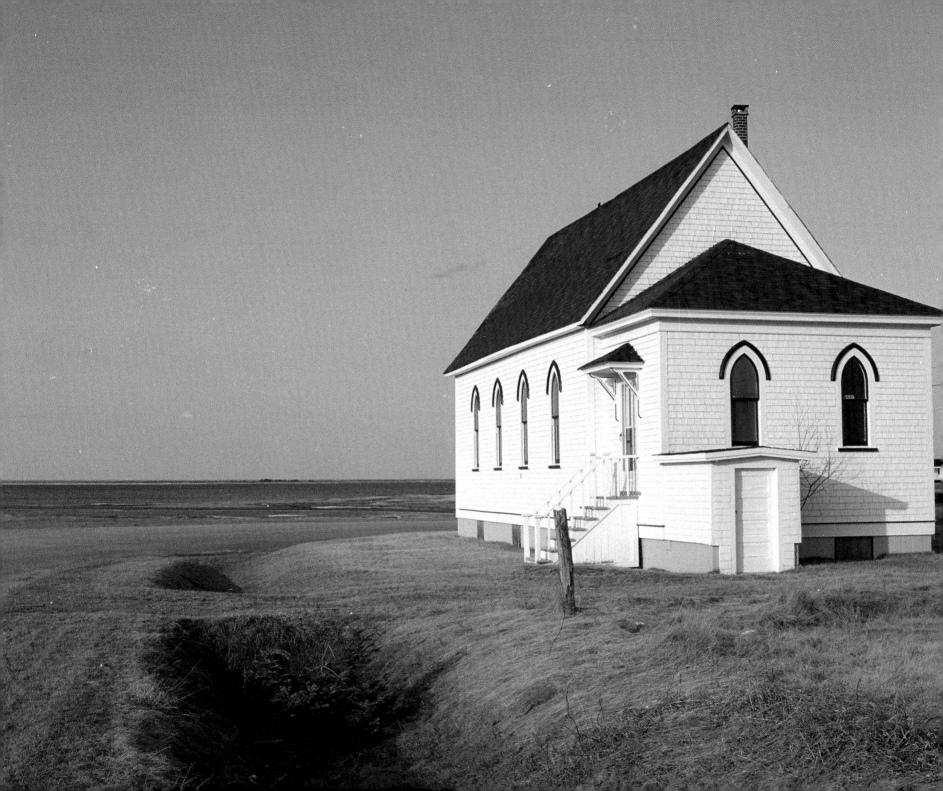

The Bay and Beyond

The bay is synonymous with fresh seafood and the Acadian fishing communities of Bay du Vin, Hardwicke, Baie Ste-Anne and Escuminac. On the north side, the Acadian legacy lives on in Neguac and Tabusintac, while First Nations traditions endure at Burnt Church. The sea is friend and foe along the bay. Residents still talk about June 1959, when high winds on the water claimed the lives of 35 men and boys. A monument at Escuminac wharf commemorates the gallantry of those who died and those who remain.

This is our river, our people, our past, our future.

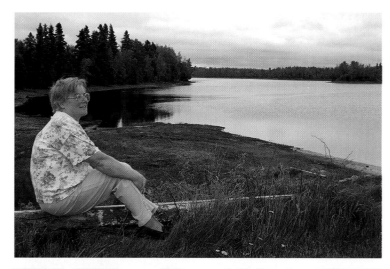

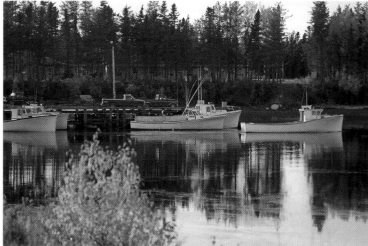

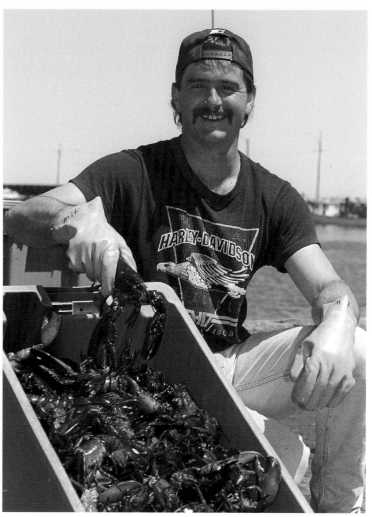

*Life force (clockwise from top left): Julia Williston contemplates a calm Bay du Vin river near Escuminac. Stormy water claimed the life of
her husband Leo Roy in the 1959 Escuminac Disaster; Michel Mazerolle with fresh lobster from Bay du Vin; lobster boats at the Bay du Vin wharf.
Opposite: monument in Escuminac for those who died in the disaster.*

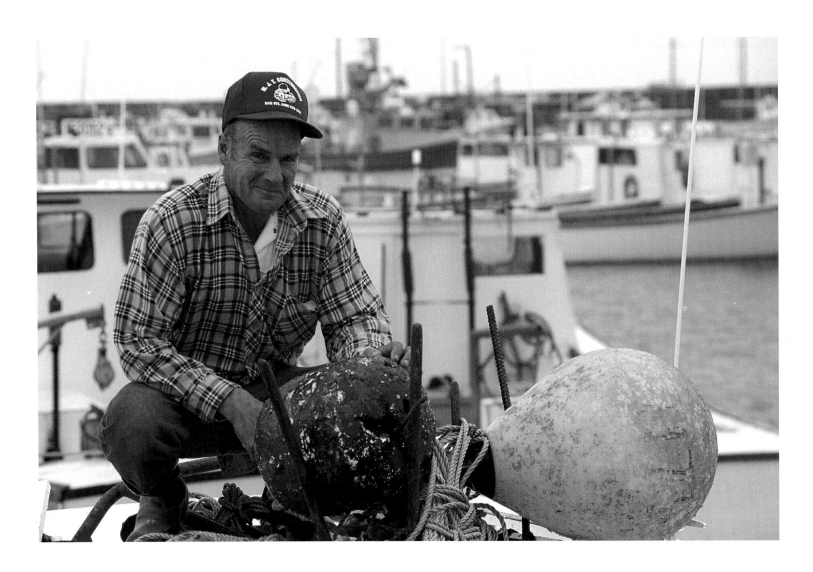

Alphonse Doucet in Escuminac harbour.

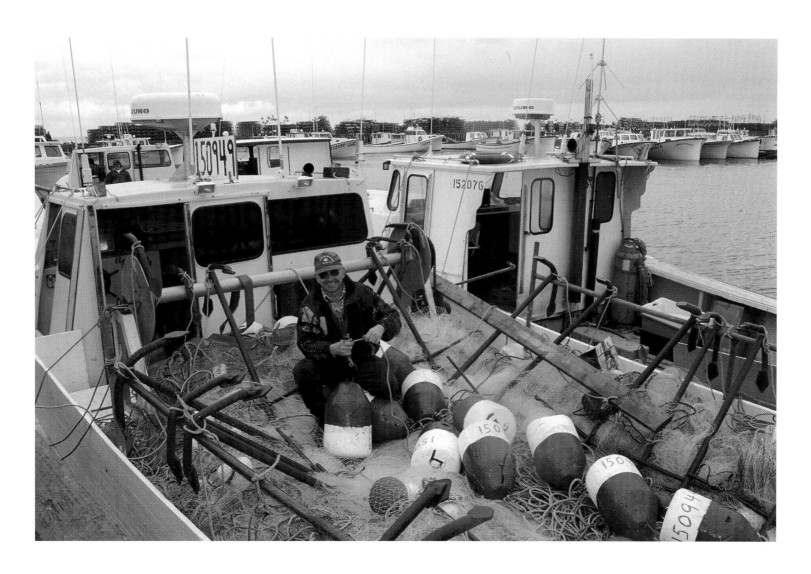

Veteran fisher Alvin McIntyre.

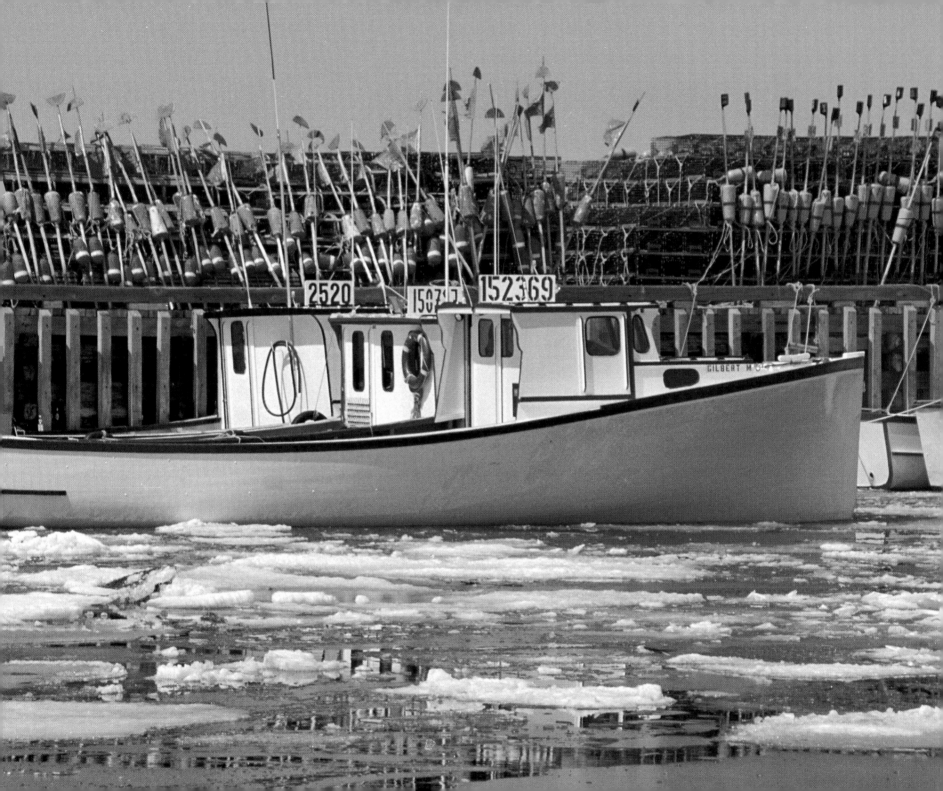

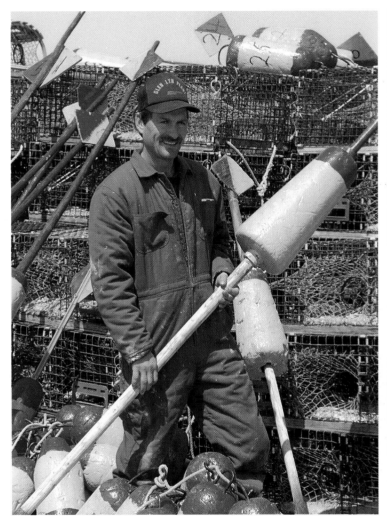
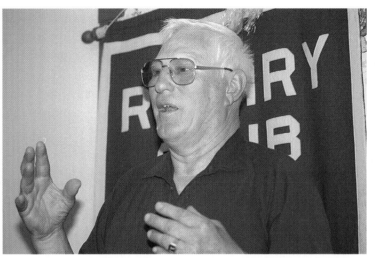
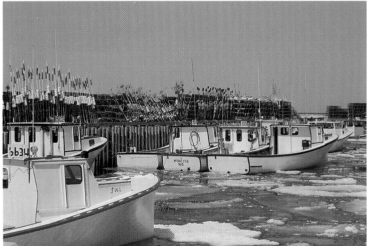

Faces of the bay (clockwise from top left): Jerome Robichaud Jr.; boxing champion Yvon Durelle of Baie Ste-Anne;
icy waters at Escuminac. Opposite: waiting for lobster season.

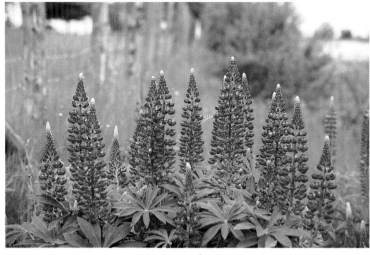

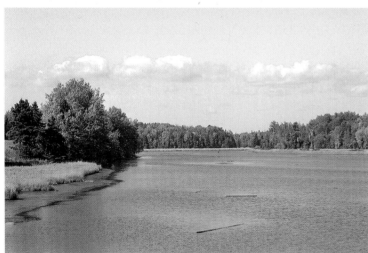

Seasonal scenes (clockwise from top left): Roadside lupins in Spring; mid-summer dandelions; Fall at Cowassaget Brook, Tabusintac.

Opposite: surveying the bay.

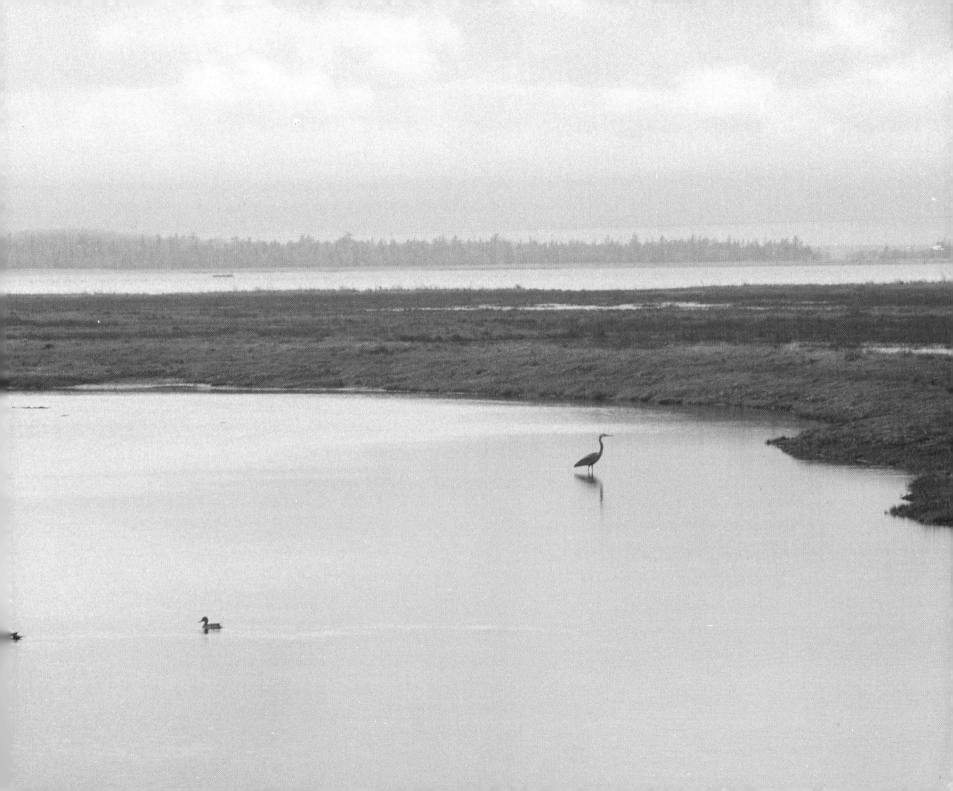

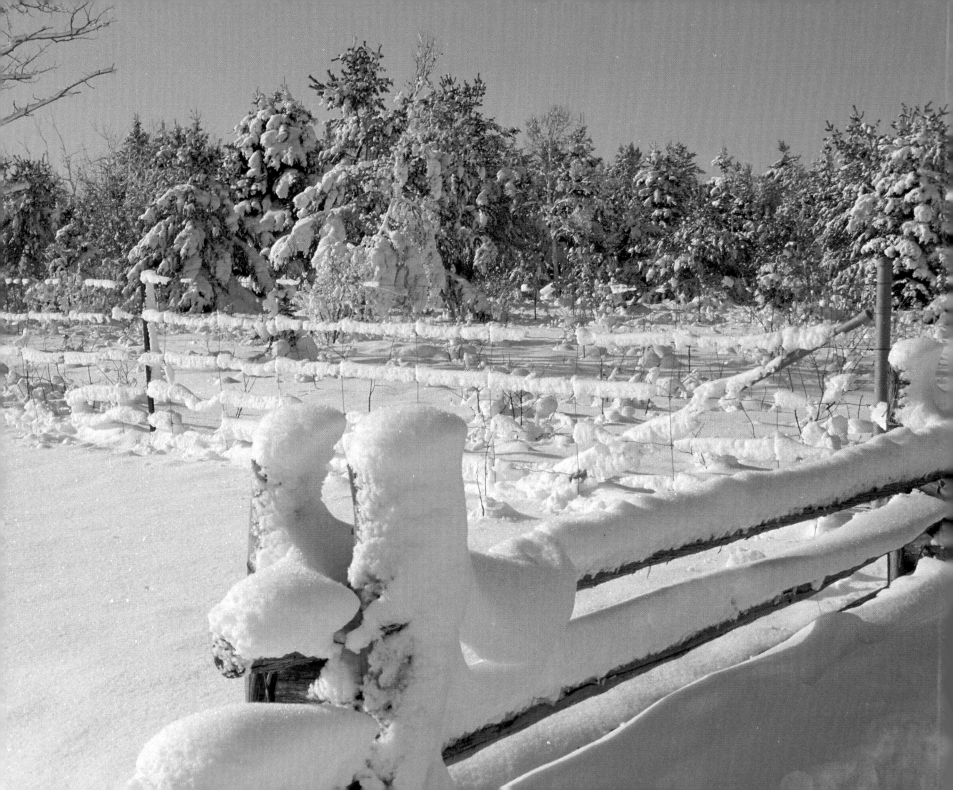

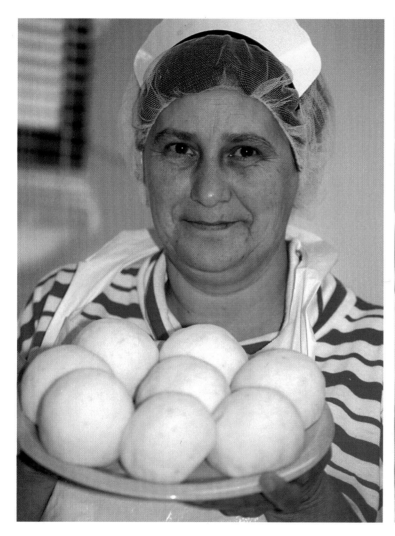
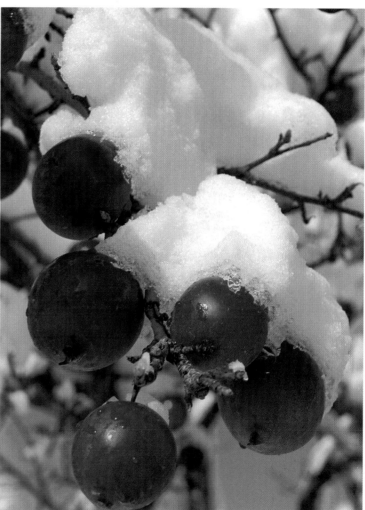

Winter largesse: Alma Savoie of Lower Neguac with poutine rapée, ready for the boiling pot (left);
tart apples (right); snowy cover in Covedell, near Neguac (opposite).

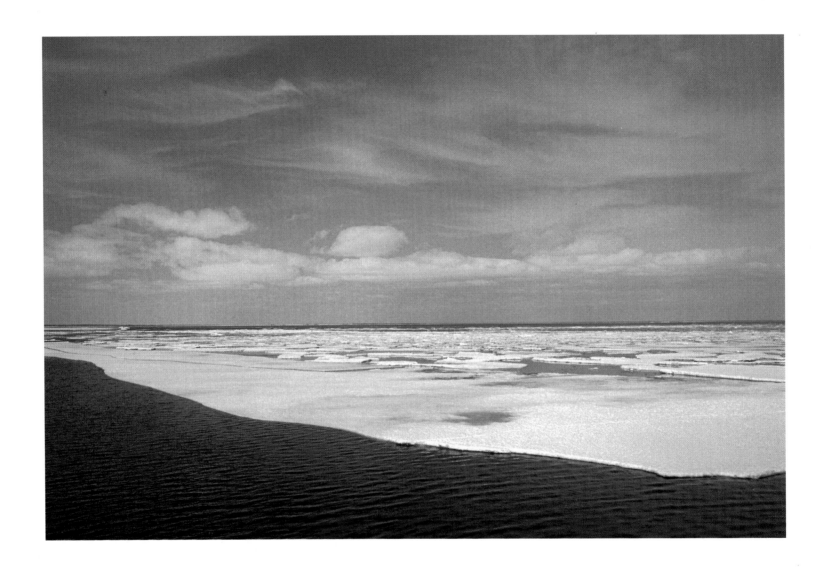

Miramichi Bay at winter's end.

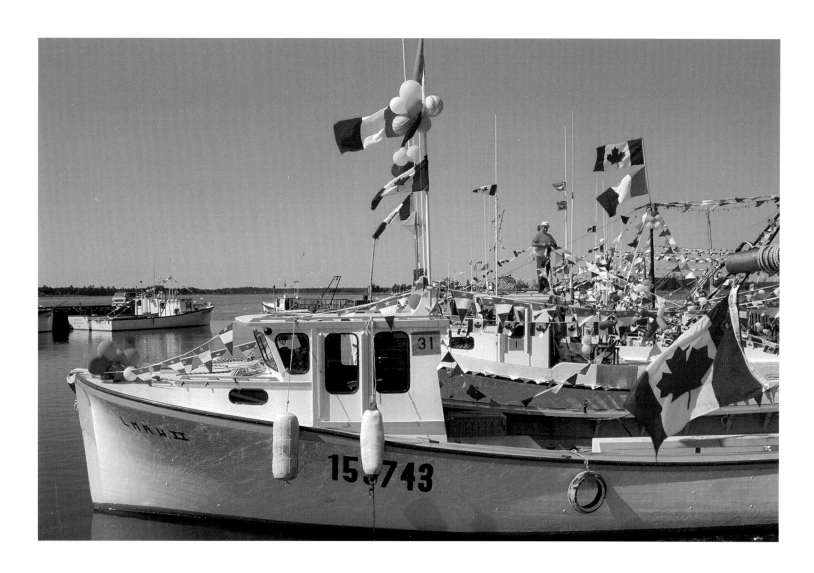

Returning home: festive boats during Tabusintac celebrations, held once every five years.

Acknowledgements

This book is the fulfilment of a dream, and it would not have been possible without the support of sponsors. It was only because of their commitment to the project, and the professionalism of the staff at Formac Publishing, that the dream became reality.

I would like to offer my sincere appreciation to all of the sponsors: the City of Miramichi; Eagle Forest Products; Economic Development and Tourism New Brunswick; Northumberland Co-op; Eel Ground First Nation; Bremner Farms Ltd.; Metepenagiag School; Miramichi Regional Development Corporation; Repap New Brunswick Inc.; Nelson Forest Products Ltd.; Miramichi Kinsmen; Harriman Burchill Insurance Inc.; M. Roy Innes Ltd.; Cadogan Publishing Ltd.; CFAN Radio; Miramichi Folksong Festival; Miramichi MP Charles Hubbard; Premier Frank McKenna; Southwest Miramichi MLA Reg MacDonald; Miramichi Centre MLA John McKay; New Brunswick Community College — Miramichi; and the Miramichi Agricultural Exhibition Association.

Also, a special thank-you to all those who have influenced my life with their wisdom, love, understanding and friendship. You know who you are, and I love all of you.

C.C.
September, 1996